Sister Wendy Beckett

on

Art and The Sacred

First published in 1992 by Rider
An imprint of Random Century Group Ltd,
20 Vauxhall Bridge Road, London SW1V 2SA

Random Century Group Australia (Pty) Ltd
20 Alfred Street, Milsons Point,
Sydney, NSW 2061, Australia

Random Century New Zealand Ltd,
18 Poland Road, Glenfield,
Auckland 10, New Zealand

Random Century Group South Africa (Pty) Ltd,
PO Box 337, Bergvlei 2012, South Africa

Printed and bound in Italy by Amilcare Pizzi SPA, Milan

A catalogue record for this book is available
from the British Library.

ISBN 0 7126 5396 1

Contents

Introduction

5

Commentaries

List of Illustrations and Acknowledgements

158

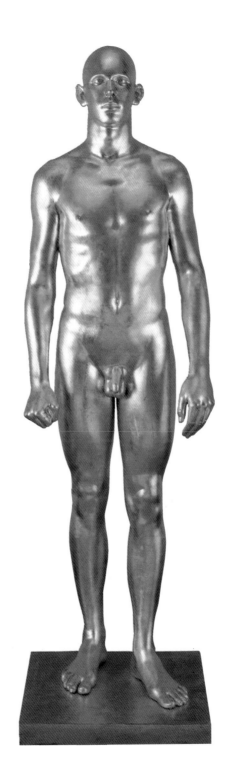

Portrait of a Young Man Standing by Leonard McComb Polished bronze and gold leaf 68⅞ × 18⅞ × 18⅞ inches

Art And The Sacred

At first sight, the Now of our present life and the mystical closeness of God can seem in opposition. The Now is down here, material, busy about many things, pressured. The Mystical is up there, spiritual, free-floating. Yet there is no true closeness of God that is not intimately related to our actual human living. St Augustine held that the human heart is restless until it finds rest in God. Even those who would hesitate to accept the second half of this statement would ruefully admit the truth of the first. In an age in which there is no longer a context of belief in God, human restlessness threatens to overwhelm us. Hence, perhaps, the growing interest in the link between art and the spiritual. The more that traditional certainties seem to falter, the more exhibitions there seem to be devoted to this theme. The largest and most influential was *The Spiritual in Art*, shown in Los Angeles in 1986, which concentrated only on abstract art. Inadvertently, this bore out a contention of Don Cupitt's that it is in what he calls 'the Abstract Sacred' that we find 'an art which is both genuinely modern and genuinely religious'. Cupitt, who teaches theology at Cambridge and is well known as both writer and broadcaster, goes so far as to suggest that this art may even be 'a starting-point for the religion of the future'. Yet Cupitt wrote this in the catalogue published by the Usher Gallery in Lincoln for their exhibition *The Journey*, which set different artworks in Lincoln Cathedral and

churches and contemplative spaces locally, and by no means all these works were abstract. It could be argued that the one work that aroused controversy, Leonard McComb's golden sculpture, *Portrait of a Young Man Standing*, upset the Dean and some of the cathedral worshippers precisely because it was not abstract, but all too real in its vulnerable humanity. The young man, a contemporary Adam waiting intently to be summoned, is a contemporary icon. Slender and muscular, one hand tightly clenched in existential tension, one hand hanging free in contemplative repose, lightly poised on the balls of his feet, looking strongly and with reverence towards his God, he gleams from top to toe, a creature of burnished bronze and gold leaf. McComb is proclaiming the wonders of the Creator of the human body. But this is a body-soul wholly exposed to his God and hence to us: he is completely naked. Before God we are all, of course, naked, and should, like *Young Man Standing*, be unashamed, prepared to be seen in all our defencelessness. But the nakedness bothered those who could not understand the symbolic necessity. These objectors, it seems, had no problem with the abstract art in this exhibition. Could it be that McComb challenged them in a way that abstract art did not?

Don Cupitt's comments are stimulating, yet he mixes together three different kinds of art, all relevant to our need for transcendence but each offering its own

approach. 'Spiritual' and 'religious' are often taken as synonymous, but they are not, or at least, may not be. Religious art, we may say, aspires to the condition of the spiritual, rather as Richard Demarco, the artist and arts impresario, means when he affirms that all art aspires to the condition of prayer. But religious art, that most demanding of the genres, may bring us to prayer by virtue of its religiousness rather than by its art. By very definition it is an iconic art, using the images specific to a religion. Christ, Mary, the Saints, the Buddha, stories from the Bible and other sacred books, from the folk tales of Islam and Hinduism, these form the content of religious art. The effect upon the viewer is in exact proportion to the depth of the viewer's faith. To those who believe, these images provide springboards into prayer. By illustrating, they remind, and the believer wants that reminder, takes it gladly and uses it as a means to God. For the believer as such, the actual quality of the art is unimportant – the work stands or falls by its ability to raise the mind and heart towards the truths of faith. These images point to them, but they do not necessarily take the believer any further. They do not, per se, deepen the faith of those who contemplate them – they activate it.

A perfect example of religious art in its strength and its weakness is the Russian Orthodox use of the ikon. The average ikon – exceptions apart – is in itself an act of profound faith. The artist prays and fasts, preparing his or her heart for the work of devotion that will be the painting. Each element in the work must be studied, because the aim is to create the traditional ikon, unsullied by the artist's ego. Submitting to the Church is an essential condition. As early as AD 860 a Church Council laid down the rules: 'What the Gospels say to us in words, the ikon announces to us in colours, and makes it present to us.' There are ikons of supremely spiritual beauty, such as Rublov's *Trinity* or *The Virgin of Vladimir*. Anyone who visits, say, the Pushkin Museum in Moscow, will see ikons able to stand up to the western masterpieces elsewhere on the walls. Yet many ikons would be judged by the unbeliever as having little artistic power. The power, they would conclude, is in the faith, not in the art. An ikon like *Saint Cuthbert*, painted in Wales in 1989, and hanging in a church in Welshpool, will move and inspire worshippers there. Every line and every colour has a meaning, and even for those who do not know the meaning, the depiction of what it means to be a priest, an ascetic, a missionary, a saint, may be silently inferred. But the unbeliever may see here only a poster-like illustration of these things, a pleasing work but without any of the power that we would call 'spiritual'. The desire to produce a work of spiritual art can never actually bring it about. This is even clearer in mass-produced religious art, like the statues of Our Lady of Lourdes or the oleographs of the Sacred Heart seen in many churches and Catholic

homes. The lover of art may find their aesthetic quality distasteful or even repulsive, yet for many devout people they have served as a vehicle to God. The vehicle, though – and this is the point – is not self-propelled. The fervour of the believer fuels it, and in this regard, the actual quality of the art is unimportant. All that matters is its religious use, its contextual relevance.

There is, of course, a great deal of art that is both religious and, in the noblest sense, spiritual. A painting like Caravaggio's *Death of the Virgin* welled up from tremendous psychic depths within the artist, and has a similarly tremendous effect on the viewer. The believing viewer does not merely find activated his or her understanding of death and the significance within our common mortality of the Virgin's holiness. This understanding may well be activated, intensely so, but in the activating a real change takes place. The vehicle, to repeat the image, moves on its own. Whatever the conceptual insights that accrue to those who practise their religion, the pictorial power comes non-conceptually. It effects what it signifies, (to use an old catechism definition of a sacrament), but the mind may be aware only of the impact of some mysterious truth. This is the essence of spiritual art. We are taken into a realm that is potentially open to us, we are made more what we are meant to be. Willa Cather, the early twentieth century American novelist, writing in *The Song of the Lark*, said: 'Artistic growth is, more

than anything else, a refinement of the sense of truthfulness. The stupid believe that to be truthful is easy; only the artist, the great artist, knows how difficult it is.' But this inner truth is not an achievement that the artist keeps for himself or herself. In making their own truth visible, the artists open up to us our own. Henry James, Cather's contemporary, wrote to H. G. Wells: 'It is art that *makes* life. I know of no substitute whatever for the force and beauty of its process.' What exactly this means, of course, is another matter, but that it has a meaning is borne out by the deep enrichment that art offers those who take time to look at it. This elusive spirituality is independent of the artist's intentions and beliefs. This is even true of religious art, where we find some of the most peaceful and prayerful religious images of the Virgin and the angels painted by Perugino, an avowed atheist. The artist's intention will always be of interest, but it may or may not be carried into visual effect. Antony Gormley, the sculptor, has remarked glumly that we can be so keen to find out what the artist intended that we do not actually discover what the work really means. Equally, we can be so seduced by the beauty of the artist's statement of intent that we persuade ourselves into seeing what is not present in the completed work. The artist may even disavow all spiritual intentions, as Rothko did, annoyed at what he felt were misreadings of his abstractions. But nobody can look at a major Rothko without feeling

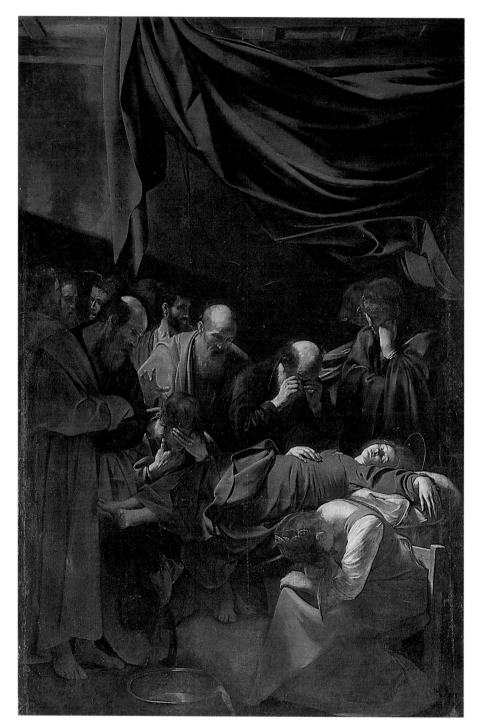

Death of the Virgin by Caravaggio
Oil on canvas
145¼ × 96½ inches

its spiritual power, being affected by it, and also being challenged. It is this challenge, this silent exposure of potential within ourselves, of a touch of the infinite, that gives force to Don Cupitt's statement on the Sacred Abstract. It is also why so many people unconsciously fear and resist art. We may not want to become aware of suppressed and unrecognized aspects of ourselves.

G. K. Chesterton, mourning our state as fallen creatures, ego-lovers, nomads in a world that we both love and feel alien to, explained: 'We have forgotten who and what we are.' And art, he said, 'makes us remember that we have forgotten'. This is painful. It is also our best means, apart from direct contact with God, of rediscovering that interior integrity. All great art, being spiritual, both grieves over and celebrates 'what we are'. It needs no religious iconography for this, and in fact, in a secularized world, only the rarest of artists, (somebody like Albert Herbert), will find that his or her deepest truth insists, whatever the artist's choice, in making itself visible in religious imagery. But the impact may be all the greater for being anonymous and pure. We may hide from God in the religious story if we choose. Unless the work is so strong – as Herbert's always is – that the artist has laid us bare to the Spirit before we can protect ourselves, then the non-religious forms of spiritual art can be more immediately effective than work in which dogmatism or narrative may be used to divert the impact.

Karl Rahner, perhaps the greatest theologian of our time, has said: 'Man is not comprehensible simply in himself alone . . . The experience of his own incomprehensibility, and the incomprehensibility of the world, and as part of that, the incomprehensibility of experience, means what we call "God".' Whether or not we agree with Rahner, (it sounds a rather remote and de-personalized 'God'), this definition may well be applied to 'art'. Meister Eckhart, another Teutonic theologian, though centuries before Rahner, wrote of the mysterious 'I-ness' that each must find in God, and added: 'Love him as He is; a not-God, a not-Spirit, a not-Person, a not-Image; as sheer, pure, limpid unity, alien from all duality.' The meaning is unclear, though the English artist Anne Grebby suggests that 'perhaps, in painting, it is possible to move through the visual, the available, the naming of things, towards a clear-sighted "knowing" vision of the unseen'. Whatever Eckhart and Rahner, mystics both, are talking about, there is a central stress on a personal truth. It is this truth, with all its negating of possible escape routes, that makes spiritual art so important to us. It is not a substitute for religion, but for those who have no other access to God it is a valid means of entering into that numinous dimension that alone makes the 'incomprehensibility' not only bearable but life-giving. It may not even be 'God' that is known as God. He is equally present in anonymity as in knowledge, all knowledge

being human to start with, and hence inadequate.

Religious art, then, may or may not be spiritual, and is recognizable by its iconography. Spiritual art is only known by its personal power. We have to seek for it, and only long and honest looking will find it. But this finding needs no special qualifications. Anyone who has eyes to see can indeed see, and as in every genuine encounter, we receive as much, (and only as much), as we are prepared to accept. The fear of making fools of ourselves, the impatience with what is too profound to be easily comprehended, the lack of confidence in our own judgement, the unwillingness to live more intensely – all these things block our approach to the spirituality of art. They are all life-diminishing attitudes though, all unconscious (but terribly real) choices of the lesser way. Our laziness and our pride both shirk the transforming potential of great art. This is tragic, we can all impersonally agree. It may seem rash, then, to go on to suggest that there is even a step beyond the spiritual, and that this is the sacred. It might be truer to regard it as the most intense form of the spiritual, the most profound and inescapable, and in this, it might therefore be more, and not, as we would expect, less accessible to those who have not yet taken art seriously. All great art, in one way or another, obviously (like a Chardin still-life) or implicitly (like a Matisse odalesque), is spiritual, but not all is sacred. Would we call Velasquez's *Las Meninas*, usually regarded as the greatest picture ever painted, or Leonardo's *Mona Lisa*, probably the best known, 'sacred'? And if not, why not? And if so, then why? There seems to be a real distinction between 'spiritual' and 'sacred', but one that it is very difficult to isolate in words. What does 'the sacred' actually mean in terms of art?

What it clearly does not mean is what Salman Rushdie takes it as meaning in the article he wrote after going into hiding: 'Is Nothing Sacred?'. He spoke facetiously in part, claiming that no, there was nothing above and beyond criticism, nothing that had irrefutable credentials. He missed the point, though understandably enough, that this criticism must be reverent, but it remains true that there are no areas of thought that are forbidden to us. We were created to be fully human – a lifetime effort – and using our minds intelligently and reverently is essential to full humanhood. But Rushdie talks throughout of *making* something sacred, whereas there is another kind of sacrality that exists of its own right. If there are events, places, people, things, that we can consecrate to God, setting them apart, surrendering them to 'the Holy', there are other areas of life where the Holy seems to impose Itself, whether we will or not. Everybody has had experience of these moments of transcendence. To be present at the birth of a child, or even to have any association with a birth; to become aware of death and its inescapability; to be lifted out of the narrowness of self by love; to be

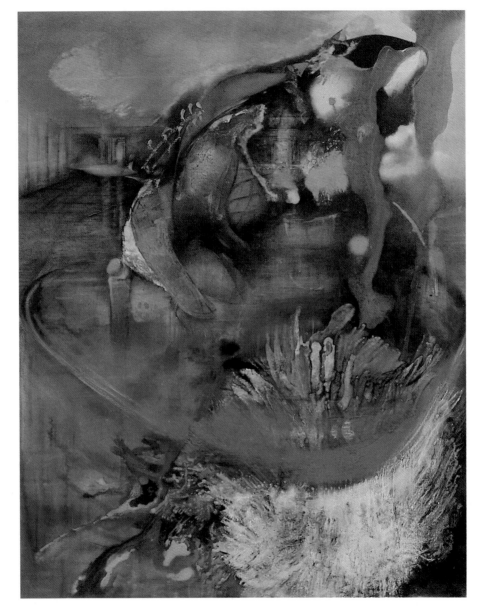

A Fire to Burn,
A Wind to
Freeze by
Anne Grebby
Oil on canvas
48 × 60 inches

*The Way of the
Cross and the
Paradise
Garden* by
Norman
Adams
Watercolour
on paper
27 × 41½
inches

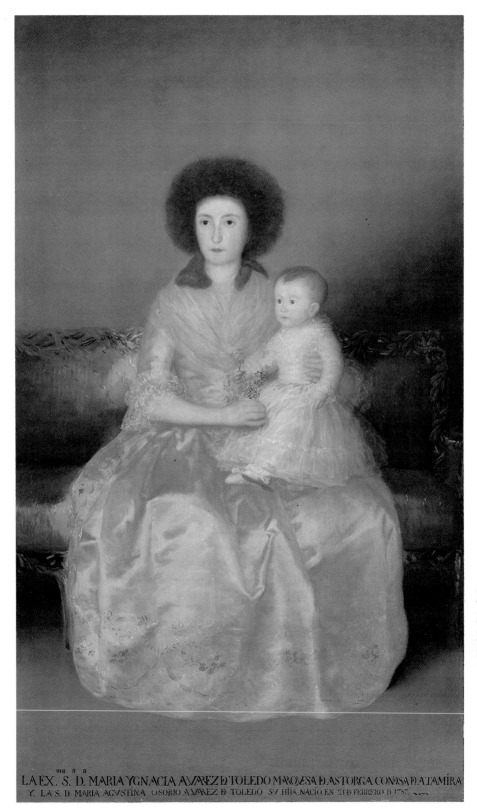

LA EX. S. D. MARIA YGNACIA ALVAREZ D TOLEDO MARQVESA D ASTORGA CONDSA D ALTAMIRA
Y LA S. D. MARIA AGVSTINA OSORIO ALVAREZ D TOLEDO SV HIIA NACIO EN 21 D FEBRERO D 1787

The Countess of Altimira and Her Daughter by Goya
Oil on canvas
76 × 45¼ inches

touched by the silent beauty of the natural world: each of these experiences is sacred, not because we have designated them as such, but just because our humanity responds to something greater than itself yet intimately part of us. Kafka, who entered so intimately into the terror of life, said once: 'The expulsion from Paradise is in its main significance eternal, consequently the expulsion from Paradise is final, and life in this world is irrevocable; but the eternal nature of the occurrence, (temporarily expressed, the eternal recapitulation of the occurrence), makes it nevertheless possible that not only could we live continuously in Paradise, but that we are continuously there in actual fact, no matter whether we know it here or not.' This is a staggering insight. On one level, expelled – that level we all know so painfully and constantly – and yet, on another level, always there, playing in the eternal sunshine. If Kafka is right, then it is in art that Paradise affirms itself within us. Art is nothing if not experience, whereas religion, though of greater import, may possess a life most absolutely without ever affecting the believer's emotions. Religion as such has nothing to do with the emotions. It does, of course, affect them, and often very intensely, but that is not the source of its power. We live our religious faith in obedience to God's holy will, irrespective of how or what we feel. ('If you love me,' said Jesus, 'keep my commandments.' It is what we actually do that reveals the depth or shallowness of our own convictions.) Art that enables us to know, not by faith but by felt experience, that 'we are continuously there', in Paradise, is sacred.

This can sound too ethereal. Don Cupitt, in the Usher catalogue, claims that Richard Long's works give us a strong sense of the sacred by 'their austerity and impersonality, and by their matter-of-fact acceptance of their own transience. They seem to speak to us,' he goes on, 'of an enduring unnameable Background against which our brief life is acted out.' If we accept that as true for Long, does it give us guidelines for other art? It seems not. Both Mark Rothko and Robert Natkin give us sacred art, yet neither is austere. The great works of Paul Klee in the last years of his life are overwhelming in their sense of the sacred, yet we could not call them impersonal. 'Acceptance of their own transience,' is literally true of Long. The circle of stones, (of which Cupitt was primarily speaking), will be gathered up and dispersed. Yet the Gothic cathedrals, those prime examples of sacred places, or the awesome dolmens of Stonehenge, have as part of their very meaning their everlastingness. We realize that no created thing does last for ever, and in that, all human works have the pathos of their mortality. But this is true for all kinds of art, not only the sacred. Cupitt's sense of 'background' is more relevant, yet how do we distinguish its presence or its absence? Does this holy 'background' rule out any playfulness in the sacred? Take then

a work like Norman Adams's *The Way of the Cross and the Paradise Garden* (1988), so bright, so beautiful that the radiance of its joy, angels somersaulting through a dazzle of colour bars, crosses of light, proclaims the marvellous oneness of the Death of Christ and His Rising. The two are different sides of the same love, and the angels, who understand this, play in its happiness. Admittedly, the word 'sacred' brings to mind a sense of the sublime, of stillness, weight, silence, majesty. Can we then see the sacred only in dark art? Is Goya sacred when he shows us *The Giant*, that terrible and tremendous image of our contingency, our essential helplessness, in a world whose laws we cannot fathom or manipulate, and yet not sacred when he shows us a dull little mother and child? Yet perhaps he never painted a more moving picture than *The Countess of Altimira and her Daughter*, a commonplace, over-dressed, pathetic little woman with her pathetic child, innocents adrift both of them, and in this a sublimely beautiful celebration of motherhood and the value, in itself, of every living creature. There are few Madonnas as profound as Goya's poor little popinjay of a mother, yet the work is radiant with light and makes no explicit claims at all for itself.

Has size any relevance to sacrality? We can stand beside a massive Richard Serra sculpture and feel awed by its unembarrassed air of majesty. The work shares with us its insecurity. Serra merely props his huge sheets of steel against one another, without bolts, supports or safeguards. Workmen who did not approach them with necessary respect have been injured and, tragically, killed. But it shares too its strength, so that we become aware, as never before, of the paradox of the body. We possess our power in 'earthen vessels'; for all our imaginative scope, we are fundamentally vulnerable creatures. Might we not describe this insight as sacred? Admittedly, to effect this the work demands its massive size, but there is an equivalent, (and some would at once say a deeper), holiness in the very small works of Roger Ackling. Ackling is a kind of anti-Serra, using driftwood, a burning-glass and sunlight. His pieces are so quiet, so reticent, so visually unemphatic, that they are easily ignored. That is a part of their significance. If we do not stop, linger, look, wait, we shall not 'see'. In one of his rare public statements (in 1990), Ackling said: 'Journeys are often a search for revelation. In this tradition some of the greatest have been made by those keeping still.' His art, showing with the utmost simplicity the marks made by time, the dark striations left by the sun as caught by the burning-glass and held against the wood, moves us almost unbearably with its sense of life-moving-inexorably-towards-death, and yet beautiful in its moving, most precious in its humility: *our* life, loved and cherished if we so choose, having a meaning beyond our present comprehension. This is sacred art at its purest, and its smallest. Size seems immaterial here.

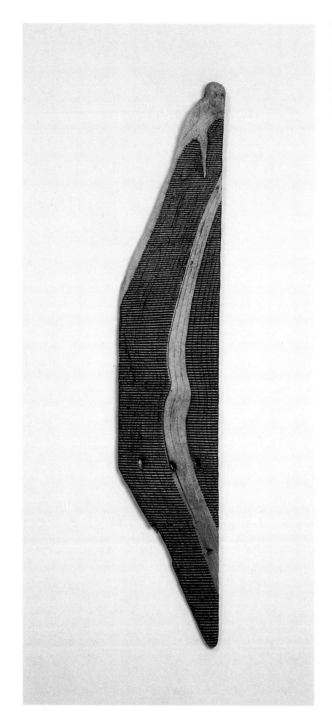

Colonsay,
Inner Hebrides
by Roger
Ackling
Charred
sunlight on
wood
$31\frac{7}{8} \times 6 \times \frac{7}{8}$
inches

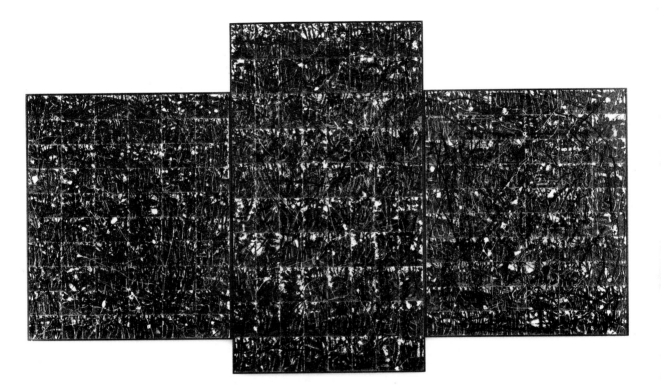

Landscape No 75 by John Virtue
Black ink, pencil, charcoal, shellac and gouache on paper, laid on board
118 × 207 inches

17

There is no problem in finding illustrations of spiritual art; instances leap to the mind. Take, for example, any work of John Virtue's. He presents us with a black and white grid of landscape squares, yet landscape abstracted into pattern, taken into the artist's imagination and its familiar shapes blurred into a mosaic of strange and beautiful forms. The ordinary has become translucent with a significance that cannot be verbalized, that haunts us and presses itself upon us, silencing the busy intellect. All art that really draws us to look deeply at it is spiritual. But sacred art is another matter. In the end, perhaps, it only comes down to personal reaction, and one man's spiritual is another woman's sacred. In 1991 Edwina Leapman and James Hugonin shared (with John Virtue) an exhibition at the Serpentine Gallery in London. Leapman's work, subtly, almost imperceptibly rippling light across the canvas, seemed to me to have the timeless weight of the sacred. About Hugonin I hesitated. Yet his art is essentially contemplative, spiritual to its heart. Could it be, I wondered, that my hesitation was caused by the butterfly brightness of his colour, those tiny lozenges of purest red, blue or yellow that harmonize together with inexplicable beauty? Yet if colour, or its absence, is the distinguishing necessity, except in the immensely oblique form of Leapman's work, where does Kandinsky stand, one of the artists who staked his soul on 'the Sacred', and in some works, at least, certainly attained it? A great Kandinsky,

like *White Border*, blazes with colour and in that very blaze reaches the sacred. The pure luminosity of the white border, foaming round the edge and intensified in the great shaft of white light that pierces through the centre, needs for its meaning the rich, deep sweetness of the colour Kandinsky uses with such sensitive intuition. Why the uncertainty about Hugonin then? Was it perhaps the bittiness of the forms? Did their kinship with the mosaic disqualify them? Yet the greatest sacred artist alive is the American, Agnes Martin, who sometimes gives us a mere grid, faintly marked at regular intervals: there is even less 'going on' than in any mosaic, yet the work could never be doubted as that intensest form of spirituality that we call the sacred. In the end, there seems no answer. Every reader will question some of my choices. I hope he or she will have others in mind that I have neglected or ignored, either through ignorance or because, loath though I am to admit it, such choices are to some extent subjective. But only to some extent. In *Foucault's Pendulum* Umberto Eco shows his characters discussing the Pendulum. 'Wherever you put it, Foucault's Pendulum swings from a motionless point while the earth rotates beneath it. Every point of the universe is a fixed point; all you have to do is hang the Pendulum from it.' To which Belbo's friend replies, half-jokingly: 'God is everywhere?' 'In a sense, yes. That's why the Pendulum disturbs me. It promises the infinite, but where to put the infinite is left

Enharmonic Series Red and Blue Overlap by Edwina Leapmann Acrylic on cotton duck 80 × 58 inches

Untitled (IV)
by James
Hugonin
Oil/wax on
wood
8 × 7½ inches

to me.' He broods further: 'Do you think there are special places in the universe? On the ceiling of this room for example? No, nobody would believe that. You need atmosphere. I don't know, maybe we're always looking for the right place, maybe it's within reach, but we don't recognize it. Maybe, to recognize it, we have to believe in it.' Put that quotation, which is almost a description ('the infinite', 'special places', 'atmosphere') of the sacred, with another remark made about the Pendulum, and by the same speaker, Belbo: 'You feel a very strong sensation . . . For those who have no faith it's a way of finding God again, and without challenging their unbelief, because it (the Pendulum) is a null pole. It can be very comforting . . .'. We are to understand this reference to 'comforting' in the context of an even earlier remark about computers and their ability to make meaningful permutations of the Torah. Diotallevi, the Jew, (at least, Jew by desire) explains to the unbeliever: 'The important thing is not the finding, it is the seeking, it is the devotion with which one spins the wheel of prayer and scripture, discovering the truth little by little. If this machine gave you the truth immediately, you would not recognize it, because your heart would not have been purified by a long quest.' The Truth, the Infinite, the Sacred, these sublimities exist, more real than we are ourselves. But to gain access to them is not easy. We cannot respond to the real sacred unless we truly want to respond, unless we

are prepared for 'a long search'. This might sound rather dismal, but it is a search of the utmost joy, opening out to us, as we venture forward, the wonders of our own potential. If this is at one level also painful, showing us what we would rather not, lazy and timid as we are, have known, it is a beneficent pain, like childbirth. In contemplating art and allowing it to reveal to us its sacramental reality, we can only make discoveries, never mistakes.

The earliest art known to us, the cave paintings of our prehistoric ancestors, seems to have been sacred art. What functional role it played, if any, in their 'religion' and daily activity, we do not know, but we do know that it was important to them. Deep in the recesses of the earth, century after century, early humanity painted images of mythic animals. They move us still, pure instances of the site-specific, drawing animation and power from the flickering torchlight and the oppression of the earth weighing down. These early ancestors of ours needed no lessons in art appreciation, no cultural guide to tell them how to respond. The knowledge of art's spiritual role seems always to have been innate. Barnett Newman, the great American abstract painter, even claimed that we have regressed as 'civilisation' has advanced, and that it was primitive people who most fully understood that art showed them a way to God, and was in itself an implicit form of prayer. What the First People had by instinct we can reclaim by

attention and desire. This book is an attempt to illustrate how we might set about it. It is still there within us, this understanding of what art can be, even if, as Newman feared, we are slowly slipping away from what was once ours by birthright. The sacredness of art is central to all ancient races, still profoundly moving as archaeology brings their work to light. We can see it in the Sumerian figures that once were votive offerings in their temples, strange, pop-eyed little statues, taut with desire for their distant god. One of the most moving is a more collected image, the carved diorite statue of Ur-Ningursu, governor of his city, Lagash. He stands tensely to attention, erect and responsible, with representations of city vassals carved beneath his feet. But the figurine is not one of human pride; inscribed on the back is a dedication to the god: 'I am he who loves his god, may my life be lengthened.' To have that as one's name – 's/he who loves god' – this is something everybody would desire, taking it as read that for each, the meaning of 'god' will differ. It is our nature to recognize something greater than ourselves and to aspire to union with it. Ur-Ningursu knows the orientation of his being, and humbly pleads for fulfilment: 'May my life be lengthened'. Even the long strict lines of his austere robe seem to emphasize this directness, always the mark of personal integration. It is not because it was placed before the temple altar that we can feel that this art is sacred.

In fact, although all early art does seem to show its religious dedication, it is not for that reason that we revere it. A cycladic idol, almost abstract in its intense simplicity, speaks to us, not of early Greek religion, but of our need to concentrate our spiritual energies and make a practical and informed choice of 'the pure', as opposed to the comforting. The wild writhings of Celtic metalwork, controlled from within by a half-hidden patterning, reveal to us our own deep need both to bring into play our passionate impulses and, simultaneously, to keep them controlled, functional in the true sense. The dragon heads on Chinese bronzes bespeak the same urgency to unify the animal and the spirit that together, but not apart, make us human. This knowledge continues right through human history, giving a fullness of meaning to Romanesque carving and Gothic overarching, one so seemingly frantic, so animal in its aspiration, the other so seemingly angelic, so inspirational in its materiality. The interlacings of scribal illuminated lettering, the great carven altars and mural decorations of medieval faith, all come from the same source: our need to pray through the visual.

Even when the ages of innocent faith are over, and we are into the age of reason, the Enlightenment, we still find sacred art welling up instinctively. One of the greatest examples is Tiepolo's *Martyrdom of St Agatha*, probably painted in the very middle of the eighteenth century. The saint was said to have been martyred by having

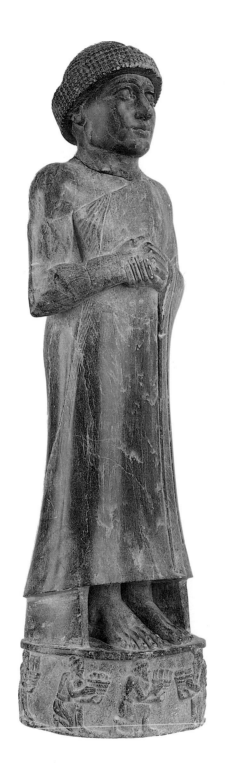

Ur Ningirsu
son of Gudea
Chlorite
Height of:
head 4½
inches;
body 18½
inches

her breasts cut off, and Tiepolo shows her to us, dying, mutilated, the cloth held to her bosom slowly reddening with her blood. She is already exsanguinated, deathly pale as she rests between the ruddy and healthy bodies of her tormentors. One carries, inconspicuous on a dish, the small mounds of her breasts. But we do not notice, or at least, if we do, it is without revulsion, because all Tiepolo's attention – and hence all our attention – is fixed on Agatha's face. She looks upwards, her eyes set imploringly on the heavens. She believes, she exposes her dying body to her distant God, (just as distant in experience as Ur-Ningursu's was to him), and she is passionate in her trust. It is an absoluteness of belief that we cannot see without being touched. Her silks swirl round her, the executioner looms, arms and bodies, clothes and people, all are in motion. Only the great supporting pillar stands motionless, silent symbol of the supporting faith that lifts her ecstatic gaze on high to her salvation.

At every period, there has been sacred art, but it has taken varied forms and we can all too easily overlook it. It is unmistakeable in Rembrandt, equally present, if to be searched for, in Rubens. Think of his most sensuous picture, *Helena Fourment*, his depiction of his young wife, naked except for the thick fur held caressingly to her plump body. She looks out at him, half-shy, half-proud, wholly trustful, acceptant of his love and her own fair beauty. The

sentence in the marriage service that affirms: 'With my body I thee worship' is made actual. The picture quivers with worship, an intelligent and truthful love of Helena's actuality, her individual fleshiness, the very feel of her, and the real woman that is outwardly made apparent through this flesh. Rubens is offering us a new richness of understanding, just as much as Rembrandt does in the sublime nobilities of his last self-portrait or works like *The Prodigal Son* or *The Jewish Bride*. There is nothing overly explicit in any of these great paintings, certainly nothing religious, but it is precisely their depth of spirituality that makes them great. When spirituality goes even a step further, attains a certain silent weight, a concentration of inexplicable 'meaning', then we may perhaps use for it the description of sacred. There seems to be that extra step 'beyond' in works like Piero di Cosimo's *Myth of the Death of Proctis*, when the sad, puzzled faun, trying to make sense of human death, and the accompanying dog, who is not called to explain this mystery, take us into the areas of ourselves, areas of mortality, where we fear to venture and yet, in a work as gentle as this, become emboldened. Caspar David Friedrich's *Monk on the Shore of the Sea* takes this step further into spirituality than in his wonderful but still illustrational landscape crosses. Altdorfer is there in his *Leavetaking of Christ*, not at all because it is 'religious', whereas his other works are not, but because he touches here on the very mean-

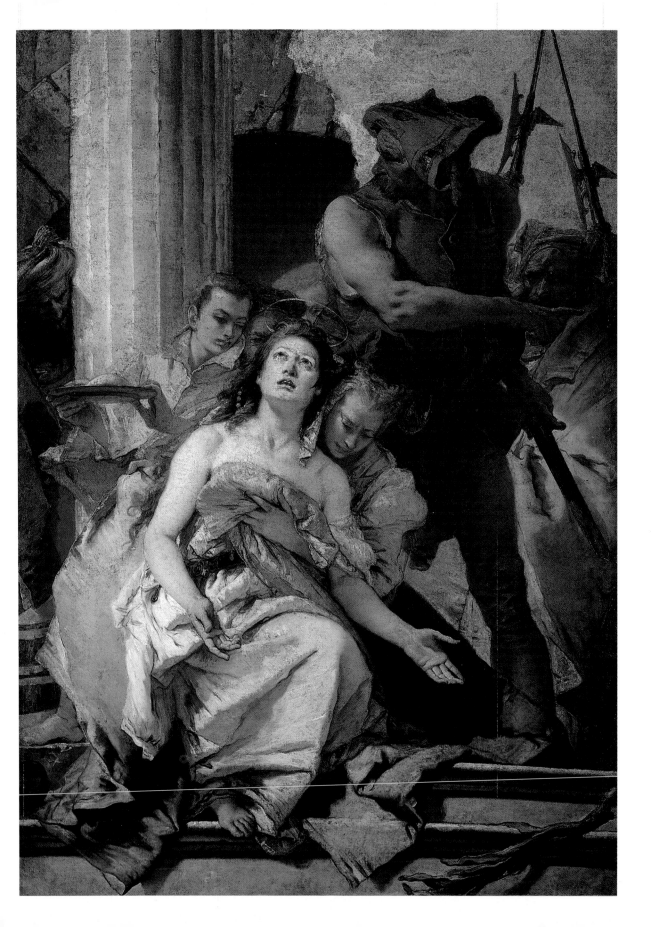

ing of separation and our inability ever to possess, finally, what we love. This applies not only to actual partings, but to our continual state of having to leave, move away, lose. Rilke puts it memorably:

Who turned us round like this, so
 that,
No matter what we do, we have
 the air
Of somebody departing? As a
 traveller
On the last hill, for the last time
 seeing
All the home valley, turns, and
 stands, and lingers,
So we live, forever taking leave.

Some artists are always in this realm of the sacred, 'forever taking leave', late Titian for one, and all the Rubens where glances are exchanged, those wonderfully tender expressions of mutual love, and all the great painful Caravaggios. Others reach this central intensity only at times, El Greco in *A View of Toledo*, but not in the run-of-the-mill despoliations of Christ or Virgins; Holbein in *The Artist's Family*, but not in the usual portraits, great – and spiritual – though they are.

In his short story *Gladius Dei*, Thomas Mann has his half-crazed hero cry out: 'Art is the sacred torch that must shed its merciful light into all life's terrible depths, into every shameful and sorrowful abyss.' Mann is preserving a certain ironical distance from the overwrought speaker, but extravagance apart, he is putting his weight behind the basic premise. We know – and Mann is well aware of this – that there is far more to life than 'terrible depths' and 'shameful and sorrowful abysses', yet these do exist, and to say politely that 'art enriches' is to imply that it does indeed shed a healing light upon abysses within. There are also, of course, joys within, and still more, wide stretches of monotony and mediocrity. These too receive light from the 'sacred torch', and once set aflame by it, can transform themselves into an amazing newness. The tragedy is that so many, imprisoned in their small worries and selfishnesses, even their large worries and altruisms, may not even know that art can make so tremendous a difference. It is perhaps most transforming when it is the art of our own or of recent times, because we are still speaking the same language, artistically, and can find a common meeting place more readily. The place is there, waiting, but whether we enter is up to us.

Craigie Aitchison

Christmas Painting (1988)

Over the years, Craigie Aitchison has refined his art to an intense simplicity. There are few actors and few colours in *Christmas Painting*, but every element is alive with meaning. Christmas is the season when we celebrate new life at a time when the year dies, when nature seems dead. Nothing grows externally, but within humanity is offered a newness of life that can become as great as we are prepared to let it be. In this painting, there is only one animate creature, Aitchison's dog, surrogate for human presence. He is alone, (as are we all), but he is also still and attentive, as all too often we are not. The Bedlington terrier is a surrogate, it seems, not so much for what we are as for what we could or should be. The dog is innocent. He is consequently unafraid of his loneliness, almost unaware, it appears, of the emptiness stretching away into infinity on either side. He does not even turn his head towards the horizon where new hope is dawning, a long, radiant line of flickering light, mysteriously empurpled. The ominous colour reminds us that our new life is destined to meet with suffering and end in death, yet the death is only temporary. The Christmas story proclaims that from now on we pass through death into life; yet the dog does not ponder these mysteries. All his attention is on the little tree, that tender intensity of colour, that crucified shape that is both Jesus and Tree. On either branch – either arm – there shines the bright green of new leaves, and the more verdant of the arms spreads itself over the head of the waiting animal. High in the darkness, in the heavens beyond reach, one slight star reiterates the proclamation of salvation. The darkness will never be too much for us, never be overwhelming: there will always be light to guide us into the divine security of God's love. But this proclamation can only come to us if we too are silent and attentive. We do not need to 'understand' it, any more than the dog does. We need only to wait, to allow the wonder to embrace us in our human reality. It is our 'animal', our true earthly self that God comes to make holy. There is no inflated imagery in Aitchison's painting; there are no spirits or angels, just animality accepted. The little dog is alight with a heavenly blueness, the beauty of Faith making beautiful.

Oil on canvas
14 x 9 ¾ inches

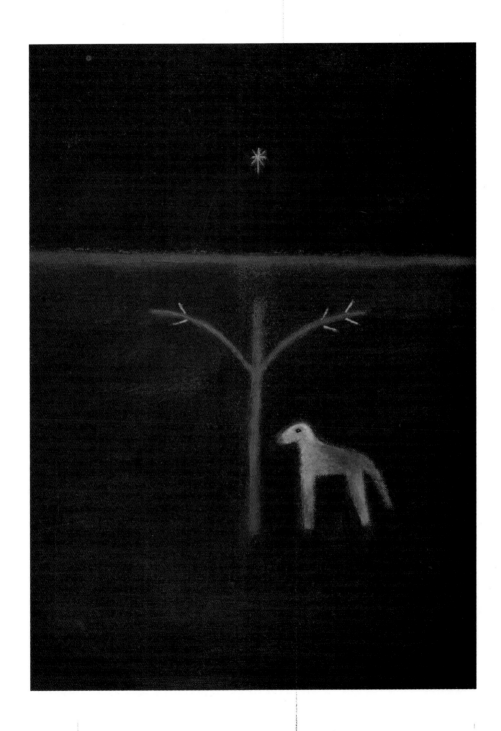

Frank Auerbach

. .

Head of J.Y.M. III (1984–5)

Frank Auerbach, one of the unquestioned contemporary masters, paints little else but landscapes and portraits, landscapes of his London setting, portraits of the same few intimate friends. In other words, his art depends, like prayer, on love and knowledge. He can only make visible to us what is deeply familiar to him, in a sense part of himself. Yet he makes this intimate truth visible with immense painterly exertions, laying and layering his oils, working and reworking his images. This impassioned denseness is his most marked characteristic, and it comes from the very essence of what he seeks for in his art. He has said that he thinks 'the unity in any painter's work arises from the fact that a person, brought to a desperate situation, will behave in a certain way . . . style . . . it's how one behaves in a crisis'. What so moves and even disturbs us in his work is this genuine sense of 'a desperate situation . . . a crisis'. Juliet Yardley Mills, whose head we see in *Head of J.Y.M. III* has been the focus of his devouring artistic gaze for many years: like a previous model, E.O.W., he paints her again and again, not, we feel, for his own sake, for mastery, not even for her sake, for friendship, but for truth's sake. Confronted with this creature, the mysterious particularity of another human, he sets himself to know her from within and to reveal her bodily being. He claims that painting the same head, over and over again, eventually brings one to 'the raw truth about it, just as people only blurt out the raw truth in the middle of a family quarrel'. He has laboured so long and so furiously, with such aching frustration, that the real woman finally forces herself onto the canvas. This particular picture is far less vivid than many, but its grey and black, its swirling yellows and the bright eye of blue, all give that reclining head a majestic presence. J.Y.M. looks out at the painter and at us. She asks for no tenderness, only for recognition. In this angry submission to the reality of another, an anger that is used, as all dark emotions are meant to be, in fuelling a search for God, Auerbach makes no sublime claims. He is only aware of his incapacity: his strength comes clearly from his weakness – a paradigm of voiceless prayer.

Oil on canvas
17 x 14 inches

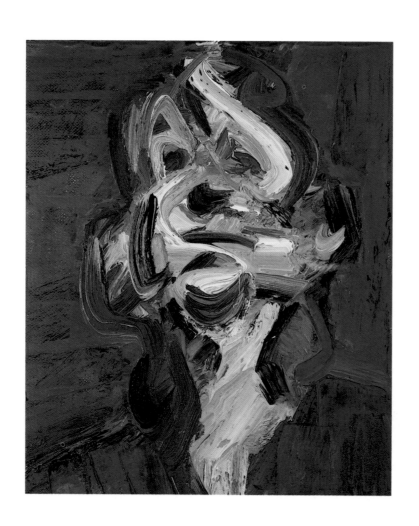

Roderic Barrett

Players (1989)

layers is pre-eminently a work that carries its own meaning within it. Roderic Barrett has said of art commentary in general: 'To write about art is in some way to dissect, and to dissect is to mutilate.' The people who confront us in *Players* are already so mutilated by life that nobody could wish to hurt them further. Our danger may be that we do not want to hurt ourselves by really looking, and so we pass over the work too smoothly. What is Barrett showing us? Five 'players', standing on a glimmering stage. (We can spy out the trestle underneath, which assures us that it is platform and not ground on which they are displayed.) Two are clearly 'playing'. The man on the far right raises his arms to beat his drum, that wonderfully glowing ova of light. Yet the man himself lifts his arms with a convulsive fury: the act seems to have a terrible intensity of protest or pain. The boy on the far left 'plays' in another sense: he holds a child's hoop. Yet closer inspection shows he is tangled up in it: the great circle, echoing ironically the full shape of the drum, is a sinister emptiness in which he is entrapped. Another kind of 'player', the actor as clown, stands beside the hoop-entangled boy. His pathetic pink pompom is the sweetest colour in the painting, but the funny hat and the striped clown garments hang together with a dismally prophetic umbrella. Here is a clown who may play for laughs professionally, but who is personally very aware that life is a wet and miserable business. Barrett does not assert this as true: he shows us that it is true for the clown he paints. The other two characters are an enigmatic Adam and Eve, playing their part in the drama of life itself. Eve, the central figure and only woman, has as her seeming emblem a crescent moon, but it has slipped from her grasp and drifts idly away. Like the man at her side, she stares blankly out at us, resigned to her exposure, mutely confronting us with her sole person. She is lonely, the rigid man beside her is lonely: every 'player' is alone, and their background of half-drawn curtain and distant theatre flats has no domestic comfort. But Barrett has shown their loneliness with such painterly beauty that we cannot despair. To paint at all is a great act of divine hope. Art accepts all the sadness, and transforms it, implicitly affirming that Beauty is essentially the presence of God.

Oil on canvas
54 × 60 inches

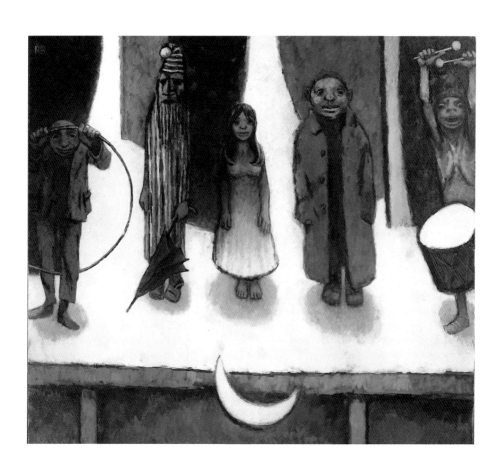

Elizabeth Blackadder

Still Life, Nikko (1987)

I f we confuse 'the sacred' and 'the solemn', we are only permitting God to come to us from one direction. It may be easier to see Him coming when it is sublime art, but the attentive eye will recognize the divine Presence equally in a light and gracious form. Elizabeth Blackadder is an artist very easy to underestimate. *Still Life, Nikko* spreads itself before us with a limpid simplicity that seems to make no demands. The demands are gentle, but they are ineluctably real. What is she actually showing us? It is a tableau without perspective, without obvious meaning. The 'Nikko' of the title and the nature of many of the objects tell us that the inspiration is Japanese. If we look up Nikko in the atlas we shall find it is a shrine in the north of Japan, and if we allow the work itself to speak to us, we shall find that the artist reacts to it with wonder and reverence. She has said, in fact, that this shrine disconcerted her. 'There wasn't the same austerity we'd come to expect of holy places.' Yet it most obviously was 'a holy place', and it is this reverent amazement that she shares with us. Over the gleaming whiteness of her paper, she spreads a personal memory of Japanese objects, either explicitly 'sacred' or made so by the craft of their fashioning, their sheer elegance. Among them she draws vague calligraphic symbols, architectural patternings, and the wild freedoms of the iris. The shrine itself is recalled by the light trellis at the left, part transparent to a multi-coloured ripple of form that suggests wave, mountain and forest. Before the trellis lie either the shoes of the worshippers or the footprints of those who have left this muddy lower world and ascended into purity. Blackadder has admitted that she does not 'wholly understand the feeling of mystery' that the strange objects of this foreign culture hold for her, but it is precisely her acceptance of her non-understanding that makes the shrine sacred to her and to us. She is entranced with its holy otherness, and in this it is a sign of all divine communication. We cannot control nor mentally dominate Nikko or any shrine: we can only allow its mystery to silence us and share itself.

Watercolour/
gold leaf on
paper
37½ ×
51 inches

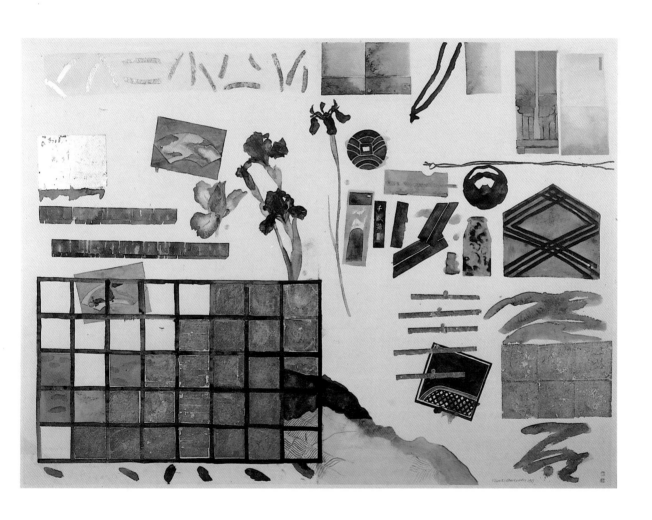

Mel Bochner

Ricochet (9.11.81.) (1981)

Mel Bochner, with his deeply philosophical mind, has been lauded as one of the founding spirits of Conceptual Art. He disputed this, pointing out that 'perceptual issues the way things looked, were at the centre' of his art. He has warned those who intellectualize about art that 'there are thoughts and feelings that cannot be discussed or that are trivialized by talk', and there is a sort of plunging passion, a wild high freedom brought under artistic control without coercion, through the sheer confidence of love, that makes *Ricochet (9.11.81.)* difficult to talk about without seeming to 'trivialize'. When Bochner adds that 'the real content' of works of art should 'move people', we can see from this drawing what he means. *Ricochet (9.11.81.)* has a geometrical structure, but it is geometry become human, tentative, doubtful. Doubt is a key word in the Bochner canon. In 1991 he illustrated an edition of Ludwig Wittgenstein's 'On Certainty' using illustration in the medieval sense of 'lighting up', illuminating an idea by making it visible. The 'idea' in *Ricochet* cannot be expressed other than as it is indeed expressed, as a drawing, but what comes to light in our emotions and our mind is the wonder of speculative courage. The drawing line speeds to and from modal points, contained within the paper support, but also within a density of shadow that suggests this containment is voluntary. There are chromatic as well as directional changes; we move with the line, meditating 'on the meaning of certainty'. Bochner, who drew his *Ricochet* series long before he was invited to illustrate Wittgenstein, says that the work contains 'the archaeology of its own doubts . . . a tissue of overlaid impulses', where 'the tangle of contradictions suddenly implodes into a drawing'. Articulate artist that he is, Bochner gives us the clue to why *Ricochet* is so immediate to the emotions of those who take time to contemplate it. We are all, as human beings, innately 'a tangle of contradictions', and we often expect contact with God to untangle us. But it can only be the other way, unless we sacrifice our personal richness of complexity. We are not erased into simplicity, but our contradictions are drawn divinely into oneness.

Charcoal and
conte crayon
on paper 27¼
× 19⅝ inches

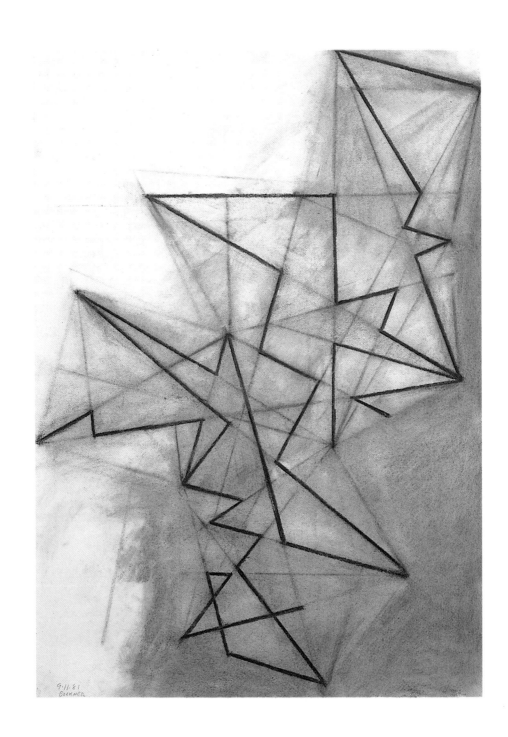

Louis le Brocquy

Image of Picasso (detail) (1983)

Louis le Brocquy, the greatest Irish painter of this half of our century, has said that for him, 'painting is not a means of communication or even self-expression, but rather a process of discovering, or uncovering'. The artist, he feels, only finds the truth in the process of seeking for it, in accepting the accidents and the travail of the labour of art. He has called the painter 'a kind of archaeologist, an archaeologist of the spirit, patiently disturbing the surface of things until he makes a discovery which will enable him to take his search further'. The implication is that there is always a 'further': if we truly search, we go deeper and deeper into the secrets of our human earth. *Image of Picasso* is one of the many 'disturbances of the surface' that make le Brocquy's portraits so unforgettable. He only paints those he knows well, taking greatly gifted friends like Francis Bacon or W. B. Yeats as his subjects, exploring with awed fascination the mysteries of their genius as revealed in their bodily appearance. Each head is held, isolated, on a great expanse of glimmering whiteness, exposed to the raking yet loving light of the seeing eye. The features fissure and fade under this impact, yet because it is the head of a man both greatly achieving and greatly revered by the artist, the bones and flesh resist, and maintain their precarious hold on visibility. Le Brocquy says that he made no attempt to paint 'the appearance, the material fact of Picasso', although we can immediately recognize him. It was the ambiguity, the 'explosive consciousness' both concealed and revealed by those features that obsessed him. He sought to create a palimpsest that might wisp into our imagination some 'ulterior image of this extraordinary man'. With all his creative skill le Brocquy has liberated Picasso from what 'appears', so as to enter into what 'is'. This is how prayer acts: we delve deep into the truth of the Other and His presence in others. We search, we wait, we refuse to take what seems. In the end, if we are humble enough, we are shown what only the patient archaeologist of the Spirit can unearth: the True Face of Love.

Oil on canvas
31½ × 31½
inches

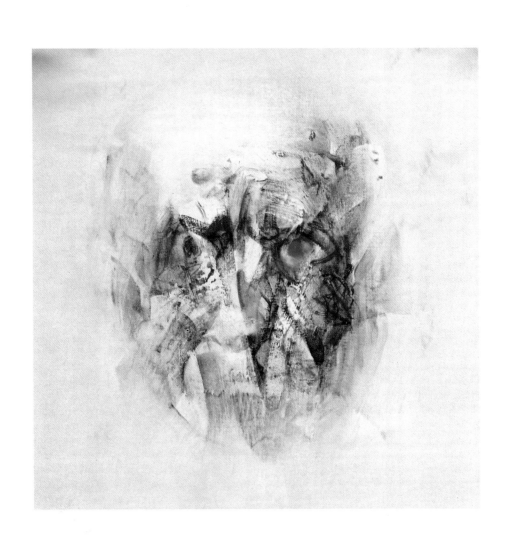

Maria Chevska

Convulsive Cloak (1989–90)

Whenever we have a diptych, we have a narrative. In medieval times it was definitely a story, with two events continuing or contrasting on either half. For a contemporary artist like Maria Chevska, the narrative is very subtle, and we gaze back and forth between the two parts of *Convulsive Cloak*, trying to 'read' it and explain to ourselves why these adjacent panels move us so profoundly. Chevska took her inspiration from folds of cloth in Titian. Their sheer beauty of texture and form drew her into feeling the need to isolate just the material, to make of it her entire picture. On the left, the folds of cloth shimmer darkly, heavily streaked, a shadowy scene, while on the right there is a radiant luminosity, full of sunlight. But the sun, which irradiates all into clarity, shows us at the centre a square of palest gold, its interior bleached out, marvellously clear, while the dark side, the 'sinister', has been overlaid with a thick and brutal red. The eye is at first affronted: the left hand square has a definity of striation and hue that seems incompatible with the soft and sliding delicacy of the whole. Chevska has used oil and encaustic, on linen as well as canvas, thickening and illumining her surfaces until they attract the light from without in addition to bearing it from within. The small inserted panel was a later addition, almost turning the 'cloak' into a landscape. (Was it a 'convulsive' addition, we may wonder, violently disturbing the smooth beauty of the surface?) What the diptych seems most purely to show is that every part can be seen as a whole: a fold from a cloak can absorb our engrossed attention, and do so under any condition. Light or dark, marked by an ethereally glowing panel or interrupted by a defiant red, the work remains serenely imperturbable. What is loved cannot be defaced or thrown into disturbance, since its security in love enables it to integrate every chance event. Chevska has cherished her painting into its beauty. She achieves with matter what matter is intended to achieve: the likeness on earth of our divine cherishing. All of us is cherished, not merely the pure or right-handed side. Discordant patches are subsumed into a wholeness: we have only to accept this cherishing, its weight and its wonder.

Oil and encaustic on linen and canvas 66 x 66 inches each panel

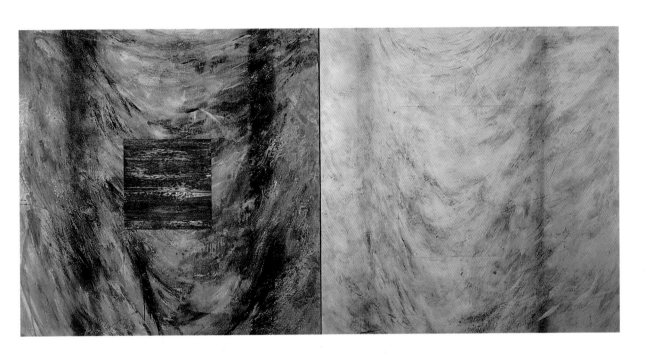

Cecil Collins

Head of a Fool (1974)

Throughout his life, Cecil Collins painted two images again and again: the angel and the fool. Both were equally important to him, one of those rare artists who held with passionate conviction the belief that 'all art is an attempt to manifest the Face of the God of Life'. Since he also saw that 'the reality of life is incomprehensible, and the Artist creates an incomprehensible image of it', he accepted peacefully that his pictures would be mysterious. There was no shortcut: art transformed us, took us out of the ego into 'vision'. The angel represented this vision at its most absolute. The angel was not human, merely our human image for expressing the Presence of God. When he showed an angel actually in touch with our earth, the angel is often weeping, wounded or distraught. The only humankind with which angels can feel at home, as it were, are the fools. Collins saw the fool as the eternal innocent, the failure in worldly terms who not only does not compromise, but cannot; who knows in his 'eternal virginity of spirit', (that lonely state of longing), something of the holy freedom of the Paradise Garden. His *Head of a Fool* shows the cost of that spiritual virginity. It is a shadowed face. The eyes do not reveal themselves to our inquisitive gaze because they are held by the 'Vision'. We receive a deep impression of interior concentration: the fool's attention is not scattered, he directs it utterly on the Unseen, and precisely in that is regarded by society as foolish. But he wears his fool's cap graciously, and it is this badge of human ignominy that seems to catch the glow of the light and radiate it downwards over his face. It is a silent face, lit from within and from without, a face simplified of the trivial and held exposed for the divine light to shine upon it. The background is a curious red-brown, an earth colour like that from which God first formed Adam. The fool can live within its earthiness and drabness because he is not dependent upon anything but God. Collins shows us the beauty of his holy folly, and also shows us the cost. At this transcendent level, with all selfish ambition surrendered, we begin to realize that between God's fool and His angel, there is little difference.

Mixed media
on board
8 × 6 inches

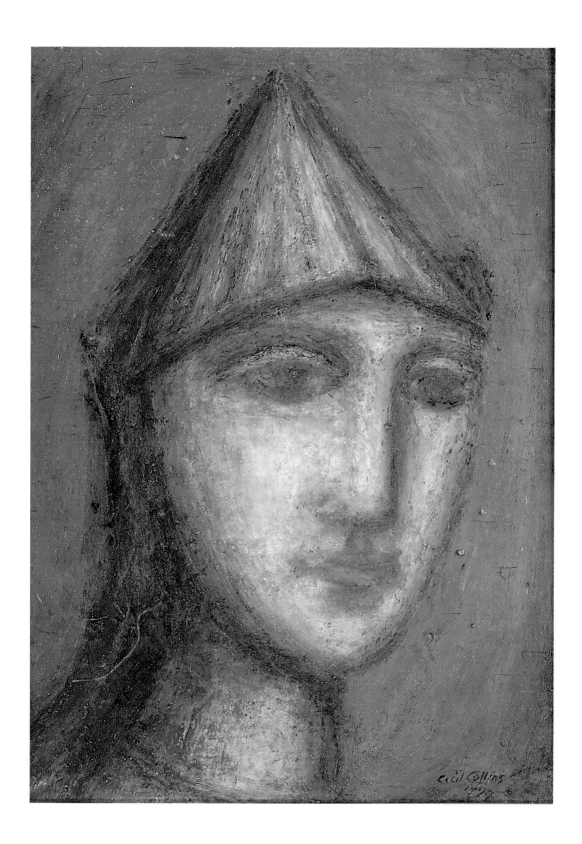

Virginia Cuppaidge

Eye of the Calm (1988)

This is a mysterious picture with a mysterious title. If 'the eye of the storm' refers to the still centre at the heart of chaos, does 'the eye of the calm' mean the chaotic centre at the heart of tranquillity? Virginia Cuppaidge is asking us to think about calm and the possibility that it flows around a core of turbulence. There is also the ambivalence of the word 'eye'. Cuppaidge suggests, subliminally, that it may be a stronger metaphor than we think. The eye may in fact 'see', be a source of wisdom for us from its placing amidst strong emotional contrasts. Certainly this powerful work arouses thoughts of great emotional stresses, but they are stresses contained. We see the deep violet of the volcano-shape at the base, throwing off wild lava flames, erupting to the four sides. It is almost as if the 'eye' is seen in three stages. First it moves serenely up from the experienced 'calm', on the lower right. Then, in the centre, it is pulled from its certainties and boils with contained furies, which spurt out in blazing reds. Finally, fragmented, it drifts away, mission accomplished, in the scattered turquoises on the left. It is a wonderful image of emotions kept in balance, peace kept vigorous but real by a central anger, and the anger, endemic to thinking humanity, both controls and is controlled by the power of peace. We experience both, not in opposition, but in true symbiosis. The 'eye' of the praying heart is always Jesus himself. His is that wise Love that sees the Father's will and knows how to surrender to it without pretence. But the Presence of Jesus is an intensely practical presence. It will never try to mask or prettify our basic truth. We do have many negative emotions, we hate and fear them, we easily seek to disguise them by virtuous unrealities. Jesus in our prayer unmasks us. He draws us to face our truth, the violence that is necessarily there at our heart, until we are wholly transformed in love. The ego is not to be denied, but to be given over to love. If we accept all that we are, God can unify and bless us. He will balance our conflicts, (not remove them), and in the balance we may become an 'eye' that can see His Holiness and live in its peace.

Acrylic on
canvas
6 × 8 inches

Richard Diebenkorn

Ocean Park 109 (1978)

There are great abstract painters and there are great figurative painters; Richard Diebenkorn is both. His early work was figurative, glowing with great wedges of colour, and then he began to feel almost constricted, labelled. Beyond what he was doing, he felt was 'the area of space, mood and light', the abstract. He embarked upon the Ocean Park series, which the uninitiated might consider well named: the paintings are immensely spacious oceans of light and air, alive with infinite subtleties of colour, like a blossoming parkland. But the title is coincidence, a name taken from the suburb in which he lives in California. Although Diebenkorn resists explanations, he has spoken of wanting to attain 'a feeling of strength in reserve, tension beneath calm'. Put in another way, he is seeking 'a pitch of right response' which can lead the viewer to 'an extreme and often physical sympathy'. In some magical way, he is bringing into being a sacred 'rightness', a beauty, not superficial, but so deep that for the artist, 'it contains the whole man', and for the viewer therefore, it will affect the whole person. Even 'physically', Diebenkorn hopes: how much more so spiritually? There are many Ocean Parks, all different, all holding in a balance of sensitivity the great outer shapes, geometrically pure, and the tender diversity of the inner patterning of tone and coloured light. *Ocean Park 109* is one of the palest in the series, but what it loses in passionate contrasts, it gains in delicacy. There are faint plays of drawing throughout, lines emerging, marking off, fading away, veering crossways and erecting grids. The softly gleaming canvas, eight feet high, over six feet wide, draws the eye deeper and deeper into its snow and cream recesses. There seems no end to its mystery. When we surrender to this beauty, we are touching upon something we can never describe in words. Diebenkorn seduces us into a sense of wonder that is close kin to worship, yet he does so without making anything explicit. He draws the whole person into a stillness in which we come to realize that there is an interior significance to the material world, a hidden dimension, made available to us in a work such as *Ocean Park*.

Oil on canvas
100 × 76
inches

Judith Dolnick

Mystery (1990)

Out of a background of deepest darkness, Judith Dolnick conjures shapes. Shell shapes? Flower shapes? Precious stones? They seem to have no specific identity, to be pure colour forms, and they float before us with the airy grace of the angelic. These luminous forms do not fight their black context. Rather, they co-habit with it and allow it its own space to breathe. Angelic purity, Dolnick suggests, has no need to fear the darkness nor to subdue it. It can accept it for what it is and take it into what it is not, but longs to be: the world of light. Everything in Dolnick's world is conscious of this light. Her forms receive the luminescence with a sort of innocence that is extraordinarily moving. We all seek innocence: we all fear we have lost it for ever. Heaven may be the place where we discover that our childhood verities, that happiness which came from ignorance, have now been refined by experience and made unshakeable. It is one thing to expect love and joy because we know nothing else. It is quite another to expect it – with total confidence – because we have known betrayal and grief, and seen through them to lasting happiness. Something of the sturdy sweetness of Dolnick's *Mystery* speaks wordlessly to us of these interior certainties. Her bright forms move easily up and across her canvas, a plethora of small innocences in search of one another. There seems to be continual seeking and then a happy finding, as forms pause beside a companion. Although the artist's control is nowhere evident, we know that it must be present, giving the illusion of freedom that we all need. Freedom is only relative for us contingent beings. Given its demonic potential, we would be carried away by our ever-present arrogance. Temperament, which we inherited and which our individual history has set in motion, for good or evil, must dictate many of the choices we fondly feel are 'free'. It is unrelenting discipline, such as we see in athletes, that alone can set the body 'free' to do what the will chooses. The discipline of love, divine love, similarly can set free the spirit to enter into the joy we know is our natural dwelling-place. Something in Dolnick's *Mystery* beckons us into this holy freedom.

Acrylic on
canvas
13 ×
12 inches

Michael Finn

Flying Crucifix (1990)

I f we have ever seen hang-gliders, we know that the human body can, with help, experience the wonders of flight. By instinct we know the stance, with arms held wide in imitation of a bird's wings, with head held high, looking hopefully upwards, with feet on tiptoe, ready for the soaring. Without the elaborate apparatus of the hang-glider, we remain solidly earthbound, however, and it is on this constant human longing, to be and do what is not of our nature, that Michael Finn is playing in *Flying Crucifix*. It is a small work, about 25 inches high, all rough wood roughly painted. Jesus spreads His arms, and soars. The cross becomes visible to us, not as what nails Him down, grounds Him, grinds Him, but as the instrument of His flight into holy freedom. Before the cross, Jesus endured the constraints of the earth. Now, having said to His Father that total Yes, having given up to the uttermost His own will, ('Not my will but thine be done'), He is enabled to go where nature cannot take Him. Suffering and death are never intended as destructions, as obstacles to fulness of being. They become so, all too often, because we refuse to give up our will and to seek in the pain the divine meaning. Jesus trusted His Father too absolutely not to hold in faith that the agony was life-giving. He experienced, scripture suggests, unrelieved anguish, including the astonishing sense (almost beyond our imagination) that He had been 'foresaken'. Yet Jesus clung in faith to the certainty that this was only how it *felt*. It could not be how it *was* because the Father can never foresake those who love Him. Relying then on nothing human, on no feeling or consolation, exposed to the naked truth of faith, Jesus is set free to soar into total joy. Finn shows this by painting the cross itself a delicate blue. It is the blue of the skies, the colour of that heaven where Jesus lives, where He most truly already is, while at the same time – because at the same time – He hangs upon the scaffold. We do not see any details of the face of Jesus. He has already flown beyond recognition in this detailed sense. He is now only a blur of warm hues, because He has so laid down His ego that self no longer limits Him to any narrow specifics. Yet He is most radiantly Himself, broadchested and austere. In its massive simplicities, the *Flying Crucifix* seems very large. This is an aspect of the paradox of its beauty: blood and pain, nails and cross have all been transformed into the glory of ascension.

Acrylic on
wood
25 × 18 inches

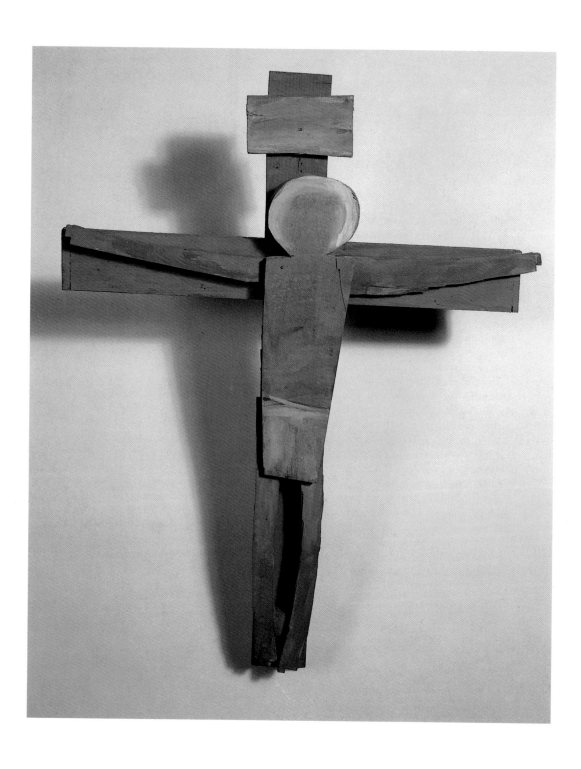

Helen Frankenthaler

Waxing and Waning (1985)

The title, *Waxing and Waning*, may suggest to us the moon, and certainly there is a sort of eerie magnificence here that would not be inappropriate. But if it is the moon we think of, then it is not as distant but as present, that active planet that sets our tides moving, both externally in our seas, and internally in our blood. Helen Frankenthaler affects us at every level. Her great floods of colour, staining into the canvas so that she makes her art breathe out of its support instead of merely from it, are colour floods that carry along the strong austerities of drawing. Her marks are not there for the fun of it, for decoration only. They are indeed gloriously decorative, but they communicate a sense of what one can only call holy glory, of the immense possibilities that are offered to those who choose life. If we wane, as all energies must, it can only be to wax more ardently, more wonderfully. Frankenthaler accepts with whole heart the chaos of our human existence, but only so as to enter into its complexities and wrest from it a fragile but lasting beauty. She has spoken of 'the glory and wonder of making art', but also of its pain, and a work such as *Waxing and Waning* helps us to understand that the two are aspects of each other. She speaks of her art being full of 'climaxes', but points out that these are abstract, that nature for her is something interior, so deeply personal that it is experienced primarily as feeling, a feeling above all of 'order'. Order is what we most need. We can sometimes attain it by limiting our living, diminishing our experience, keeping ourselves safe. But this is not the order of holiness, God's order. His comes not despite but through wildness and disorder. The unpredictability of nature is one of its symbolic functions: it forces us to accept our own contingency, that it is God's world, and not essentially our own. But it is, too, our own: we are stewards, and we live in it. Frankenthaler opens herself to nature in its wild innocence, and then, in the mysterious poetry of her art, she shapes the wildness, the 'climaxes', into a prayer-like peace, that both exhilarates and quietens us.

Acrylic on canvas
68¾ × 113⅞ inches

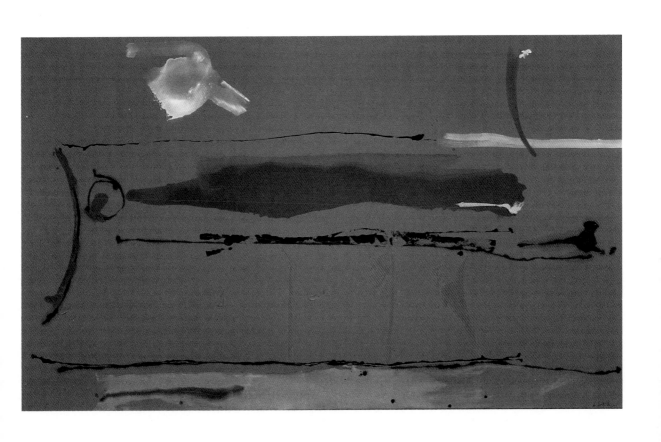

Franz Gertsch

Doris (1990)

Aphotograph can seem to us (wrongly) the easiest of art forms: it is at least potentially the quickest. A woodcut, on the other hand, can only be achieved by long and deliberate work. From Dürer's day to our own, chisel on wood, painstakingly chipped, brings into being this 'carved' image that only appears when printed. Franz Gertsch not only unites the two techniques, but he adds to them a third. He only prints one print of each image, onto thick and special paper, nine feet high, a living tissue made for him by a Japanese paper maker. *Doris* is a giant head, presented to us without background, ethereally pale. The image is projected onto the woodblock from a photograph, and then Gertsch chips away, one minute dot at a time, creating an image he will not be able to see until the final printing, but which any small manual error will destroy. Once printed, the density or looseness of the dots will provide the face of the girl with all the subtle modulations of light and shade that would otherwise come from the use of painting techniques. It is an extraordinarily slow, dangerous and poetic method of showing us the spiritual beauty of the human countenance. It is 'a spiritual beauty' because the face we see is so wholly removed from the everyday likeness of colour and substantiality. *Doris* floats against the wall, dissolving into small dots if we crane up at her, returning to distant visibility if we step back. She is both present and absent, both soul and body, both possessed and forever distant. The size alone is transfixing. Gertsch originally painted these huge female heads, and museums that exhibited them found that one alone was enough to fill a room with its gentle presence. But these paintings, however lovely and absorbing, still seemed to the artist too accessible. He needed a deeper mystery, at a much further remove from anything that could be seen as 'biographical'. He sought what he called 'facial landscapes', in which 'points of light' draw the image into a grandeur that is innate to humanity, but which we so easily ignore. What he prints are images of love: what we are shown in *Doris* is there for the seeing in everyone.

Woodcut on
yellow
Japanese
paper
96 × 72½
inches

Maggi Hambling

Smiling Sunrise (3), Suffolk 16.8.87. (1987)

We know, in fact, that the sun does not 'rise', but that the earth moves. And because the earth is always in motion, cannot be still, and in its motion carries with it ever-changing climatic conditions, so must every apparent rise of the sun be different. Yet out of our inability to see reality and not appearance, and also out of our worldly inability to be still, comes the glory of the sunrise. This is what Maggi Hambling, that profoundly contemplative artist, offers us: the almost metaphysical glory of this diurnal event. Few of us today rise to see this rising. We know it intellectually, which makes another level in the work's complexity. Every time it occurs, there is a startling uniqueness to the event. Here Hambling shows us *Smiling Sunrise (3)*, and carefully documents it. She saw this on the 16th of August 1987, late summer, when autumn was about to mellow the earth beneath. Some of her sunrises are hostile, even frightening. This one, as the title tells us, is benign. It is also wholly beautiful, an explosion of radiance over the dark countryside, low and flat as is usual in Suffolk, and all the more able therefore to receive the radiance. The picture could be an abstract centred around the empty space that shines too brightly for the eye to dwell on it. That technically, the emptiness is the only way to represent the sun, is another essential paradox. Such art may seem simple, but the implications of its visual power go very deep. We are personally put to the question. Through our own willingness to experience Truth, to labour until we can 'see', to allow our ego heights and depressions to be laid smooth and made receptive to brightness, many fears and lazinesses are most delicately laid bare. None of this is forced. Hambling shares with us only her wonder at the sunrise, but because that wonder comes from her depths, it speaks also to our depths – or perhaps shames us with our want of depth, inviting us to make that want, that lack, a longing, a prayer. Sunrise, to Hambling, is implicit prayer, a glory to Transcendence, a silent hymn of praise. The silence is the secret of its power. Prayer accepts its poverty; it reverences, and is still.

Watercolour
19 × 24
inches

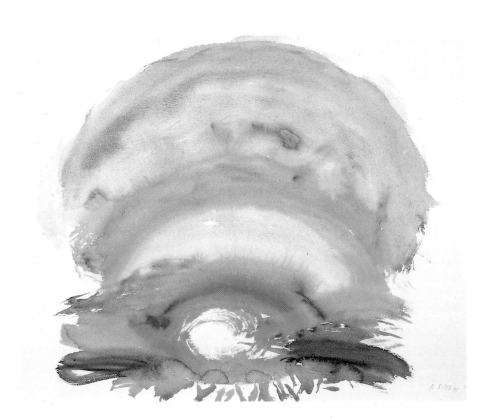

Marcelle Hanselaar

Chronicle of Wasted Time (1987)

Marcelle Hanselaar is a painter of intense power, banked-up power, power that seems to force itself onto the canvas in colour and form. There are hints of images here, but all we can at first see with certainty is the great red sun, low in the darkening sky, sinking inexorably to a dark horizon. But light still glimmers brightly on the central mass, with its sense of desertion. Are those dead flowers spilling from an overturned vase? Or are there limb-like shapes on the right? Is the flooding red on the left, background? Our uncertainty in itself conveys a message: this is a chronicle of wasted time, so shapelessness and incoherence are in keeping. This is the plotless tale of a life that has not made harmony from its innate chaos, and is now revealed in its helpless failure. This is a dark theme, and the work weighs down upon the viewer. But – maybe because of the glowing vitality of that sea of red, the alertness of the touch of bright pink, the sheer beauty of Hanselaar's paint – we become steadily less and less inclined to sadness. Time is – time has already been – redeemed. The lost sheep is sought for and carried home, the prodigal son is welcomed and given an honoured seat at his father's side, the dead are raised. The silent message of the work, carried subliminally, is that time is wasted in our small ego-world, but there is nothing lost with God. How does He redeem our wasted time? That is His mystery, but all that happens to the sinner, good and bad, is matter for his redemption. The key is to be able to admit that we have failed. The chronicle is painful for human pride, but it is a setting free, a letting go of the petty ego that imprisons us in its limitations. God's life, His heavenly world, is that vast delicately nuanced sky that spans our collapse. His redemptive Sun enlightens all that we are. He has no condemnation, only the affirmation of His redemption. These fallen and pathetic masses do not need to plead with God for mercy, to be made whole. Their very being pleads, and is immediately heard with the power of His love. 'When I am weak, then I am strong,' said St Paul. All I have wasted, God's love has restored and made lovely. I need only surrender to Him, in peace.

Oil on canvas
32 × 35½
inches

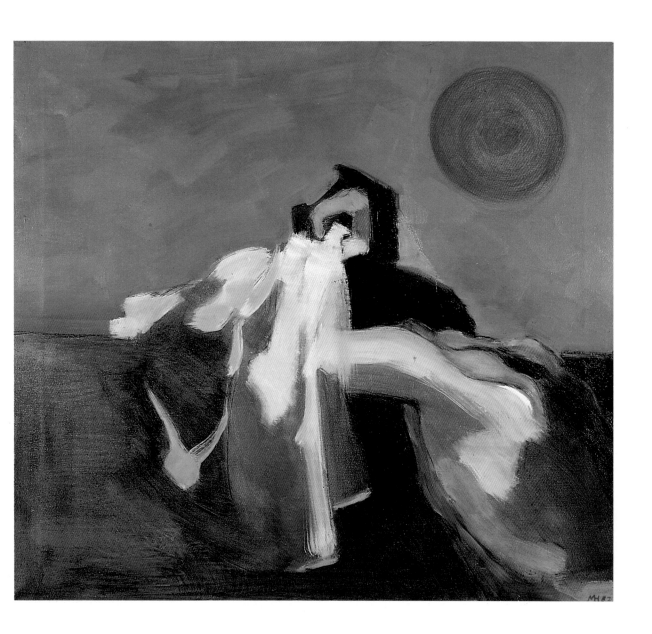

Dereck Harris

Singular Figure (1988)

Dereck Harris is a young Welsh artist, and *Singular Figure* may at first suggest to us the brooding melancholy said to characterize the Celt. But the effect of this solitary figure is deeper than mere melancholy could produce. Melancholy, depression, look inwards, akin always to self-pity, that destructive emotion. This young man sits, half-naked, in an unpeopled world. Mists hide the far stretches of country to his right: is it plain or hill? And on his left arise branchless trees, remote, hierarchic, like slim ikons of intercessory prayer. We do not see his face, only the tensely waiting back, exposed and vulnerable. He is both singular in the sense of being alone, and in the sense of being unusual. Yet Harris does not seem to strive to interest us in any narrative. We feel, perhaps, that we are looking at the figure of Everyman, that it is generic human singularity that engrosses the artist here. The human creature is alone, without protection, waiting on into the twilight for some inexplicable meeting. The tall and urgent trees suggest that Nature will parallel this longing, but cannot in any way assuage it or offer an 'answer'. The human cannot see into the dimness of the future, which is not available to humanity even in imagination. So we wait, and we commit our nakedness to God. Although God is nowhere indicated here, it is the sense of a numinous and unseen Presence that makes this painting an image of prayer rather than of some futile reverie. In prayer too, we wait, defenceless, unable to grasp our position, helped only by our trust and not by any natural support. And, like prayer, the picture is intensely beautiful, not for the figure, who sees nothing but remains attentive, but for the onlooker. It is we who look on Harris's lovely image; it is God who looks on at the lonely figure at prayer. Prayer discloses to God the whole of what we are: we open ourselves to His gaze. Whether in common worship or alone, the decision to trust Him must be singular, made in the truth of our own hearts, the result of our own choice, the choice He makes within us, if we offer Him this freedom.

Oil on canvas
61 x 58 inches

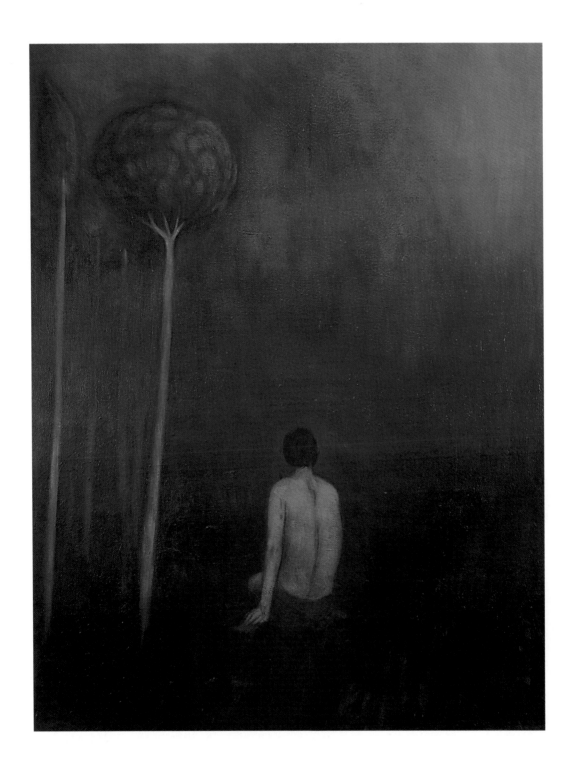

Be′ Van Der Heide

Kaş (1990)

Although we know that landscape is objectively there, outside us, it may only become subjectively there, fully visible, when it is also within us, when what we see expresses with power what we are feeling. It is this landscape of the heart that attracts Be′ Van Der Heide. *Kaş* is a dark and stormy scene, where strange shapes struggle to become visible on the edge of our vision. 'Vision' has both its meanings: what is seen and what is believed in. This landscape, dark though it is, has nevertheless an exhilarating sense of wonder. Travelling on the Turkish coast, Van Der Heide was constantly drawn to the distant presence of sacred tombs. She has painted a series, the Lykian Tomb series, of which *Kaş* is one. These fortress-like structures, crowned with the odd turret, massively impregnable, were the dwellings of a dead people of whom she knew little. Often they crowned a lonely hillside, as here, the earth falling away before them into eerie ravines and crevices. There were caves too, darkly impenetrable, hinting at other ways of revering the dead. Always above, either literally or in spirit, Van Der Heide saw a rolling brightness of sky, billowing with storm cloud but luminous all the more because of the darkness. The earth receives and partakes of this brightness, with crimson welling up from the deep browns and the constant gleam of gold. Death is the ultimate mystery, one which we shall all most certainly confront and which we shrink from internalizing. Tombs are, in themselves, shapes with which we cannot feel at home. Yet, this darkly radiant picture intimates, might not the mystery of death be an entry into life? These tombs are profoundly living. Their presence dominates the countryside. Tombs are only reminders, only directives towards what their long vanished inhabitants now experience. Their stone barricades protect only dust: the person in whose honour they were raised is no longer present. Where then are the dead? What is left of the people who were felt to merit such nobility of entombment? Do the solidities of the tombs mock the builders' hopes? Whatever the verbal answer, the subdued glory of *Kaş* gives only the reply of wondering hope.

Oil paint – on
acrylic –
garden peat,
charcoal, on
canvas
79 × 67 inches

Albert Herbert

Jesus is Stripped of His Garments II (1987)

One may define an artist as a human being who is forced to be truthful. An artist's conscious intentions are always at the mercy of inner necessity. A work of art is not what an artist necessarily wants to do, but what is forced into visibility from within. Religious art in the strict sense makes this painfully clear. Many an earnest Christian has sought to express in paint deeply held beliefs, and all that emerges is pious illustration. Genuinely religious art either comes from a level beyond the artist's control, or it does not come at all. Albert Herbert is a supreme example of this truth. As a sophisticated teacher in an avant-garde college, he resisted the simplicities of biblical art, but it forced itself into being. *Jesus is Stripped of His Garments* is from a series of Stations of the Cross that Herbert made for a London church; they were rejected, and we can understand why. This image, arising from the depths of the artist's psyche, has a terrifying truth. Jesus is in a nightmarish situation, with leering faces of rejection of all sizes, all scornful, all powerful, ringing Him in on every side. Claw-like hands reach in to strip Him; He experiences our ultimate fear: to be exposed to our mockers. Jesus is literally exposed; the enveloping garment of His public persona is being ripped away, and the small inner Man is derisively unpeeled. He is small, no hero. The enemy exults and jeers. The slight and unheroic Jesus looks up at them, not in anger, far less in self-protective hate. He faces them bravely and nakedly. He enters into every creature's nightmare, not to triumph over it but to endure it and He accepts with courage His own stripping. What makes this image so terrible, and surely why it was refused by its commissioners, is that the savage delight in the downfall of God and the greedy hands thrusting at His clothes are our own. It is we who do not want God to be God to us, who seek to undo His dignity and remake Him in our own ugly image. We fail, and the Holy One who is stripped of His protections, (a theme that comes from deep within Herbert, who has also dwelt with fascination upon Jonah and his protecting whale, Noah and his protecting ark), puts to us an unavoidable question: are you for Me? Or against?

Oil on board
14 x 11 inches

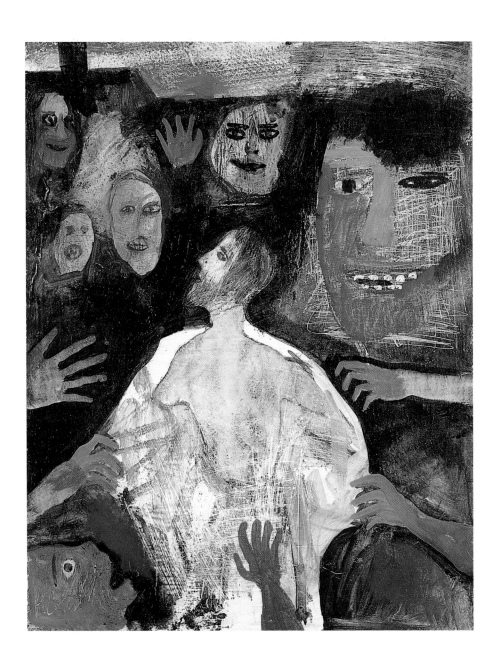

Paul Hodges

Paho (1990)

Paul Hodges says of *Paho*: 'It is a statement against the wanton destruction of wildlife and habitat. Whilst acknowledging the North American Indian tradition of attaching prayer feathers (Paho) to sacred trees, I wished to pray for an end of the killing of "game".' Much contemporary art bases itself upon 'making a statement', and all too often that is all it accomplishes. The statement is useful and only art can make it, but the effect is only specific: it is not art that touches the whole person, and hence is not infinitely alive. Paul Hodges, grieving over human greed and cruelty, goes beyond environmental specifics. *Paho* cries out on behalf of all the weak ones of the world who still cling faithfully to their God. Even if they do not call on any 'named' God, their pain is directed implicitly to the Holy One. The prayer tree that Hodges paints is hardly recognizable. Its branches are like human and animal bones, dead white, twisted, built up into an accusatory grove of vertical pain. Their sharpness scratches at our complacency. Yet the accusation is beautifully softened by the acts of repeated faith, which have solemnly attached to these dry bones that were once living tree, so many feathers from what were once living birds. The bird is a symbol very dear to Hodges: to him birds are the 'spirit of the air', essential freedom, which we will not accept or allow in others. He cherishes feathers, as do the Native Americans who offered the spirit of freedom, the feather of the bird, to the god of the wind, by tying it to a tree in petition. These feathers are almost rigid with the force of the wind, the power of the Spirit. They fly at right-angles to the branches, only held to the earth by the coloured cords of the petitioner. The cords are multi-coloured, perhaps indicative of the various living tribesfolk who have carefully and lovingly attached them. The glory of the feathers and the firmness of the cord together make 'the prayer'. Every element in this simple ritual is one of reverence, that humble living attitude that alone enables us to enter into communion with the Reality outside our own narrow ego. Although no words are said and there is no communal liturgy, this is true worship, the only way for every human heart to follow if we are to enter into the divine compassion from which *Paho* arises.

Acrylic on
canvas
48 × 72 inches

Andrzej Jackowski

Holding the Tree (1988)

In October 1988 England was swept by what has gone down in history as 'the Great Storm', a hurricane-force wind that uprooted ancient trees and devastated the countryside. On one level Andrzej Jackowski is recalling that terrifying night, when conventional certainties seemed to have been violated by the wild forces of nature. He actually saw, as did others, great trees flying horizontally through the air. But the Tree here is not flying – the point of the picture is that it is a held tree – and the tree-holder has a dreamy half-smile. Before this giant face the tree seems like a feather, and yet Jackowski has kept intact its arboreal dignity. The trunk is arrow-straight, and the leaves fan out serenely and unperturbed. The tree can afford to remain calm. Though uprooted, and no longer vertical, it is nevertheless 'held'. The tree is safe. The huge hand that holds it does so very delicately. On the earth we see ravines of subterranean blue, as if deep and hidden springs have begun to flow, and around the waters there blaze up small flames. Like fiery stitches, they appear to lace together the fundamental agitation of the terrain. Above, the skies are filled with regular rows of dark cloud splashed with crimson: blood or fire? Whatever it is, both below and above is danger. Only the tree is safe, caressed by the mysterious giant, who in human terms remains inexplicable. Jackowski has said that he wants his pictures 'to serve as keys for people to unlock, or enter into, their own self'. He persists that he does not want 'to paint riddles', but he admits that these enigmatic images, these 'revelations, appear to us as riddles'. We are not meant to unravel them intellectually, but rather to respond to their poetry and ponder quietly the emotions these visions arouse. Those flickering fires, for instance, he sees as a recreation: 'I see the burning ground as a remaking', a divine renewal of a spoilt land. This may sound puzzling, yet the actual response of our imagination to the painting is not of death but of life. *Holding the Tree* is a strangely comforting image - though we can never work out how, we know at some deep level that we are 'safe'.

Oil on canvas
50 x 119 inches

Bill Jensen

The Vanquished (1982–83)

Bill Jensen paints small pictures, (*The Vanquished* is 36 inches by 25), and they have a curiously concentrated intensity. Thickly encrusted paint makes urgent movements, enigmatic shapes twist themselves in some earnest but inscrutable search. There is a strange feeling that we understand what we are looking at, that we have somewhere seen these forms, but we cannot at the moment put a name to them or decipher what the work means. This disorientation is endemic to Jensen. If he allows us to take control, the passion will be dissipated in relief. While we are 'held', kept guessing, the magic of what we see can get to work on us subliminally. Jensen has described how he starts 'searching for the awesome quality in the painting. It can become very frightening, very threatening.' Elsewhere he speaks of sometimes attaining a 'serenity' in his works, something he loves to happen, and yet how he can know that he has to 'push them further. I know that when I go further, something else is going to happen.' What will happen will take away the comforting serenity, and so his work will 'vanquish' him, will take him to challenging and unsafe places in his psyche that he would not consciously choose to enter. Perhaps *The Vanquished* comes from this defenceless area. The whole surface is alive with intent forms. White tendrils jut from the black like thorns, and there are two sets of the tight spirals so common in his work. But it is hard to ascertain what exactly is happening, and what the bright petal-like, oar-like spray of yellow is achieving. The answer is that these are not forms copied from nature, but Jensen's own inventions, and their eager activity is essentially mysterious. We are not central to our world, though our pride makes this hard to accept. Not only do we not understand it, but we do not even observe it. Amidst great visual poetry, we can live semi-oblivious. Jensen seeks to wake us up, to arouse our spirit, to summon us to a purity and intensity into which we are too slovenly to venture. All he paints is alive with this secret Spirit, this deep call to an awakening. If his art disturbs us, it is only to draw us with it into wonder. Can it be that 'the vanquished' are the deadweights of conformity and self-sufficiency that a work such as this triumphantly casts out from us?

Oil on linen 36
x 25 inches

Jasper Johns

Map (1962)

No contemporary artist has been written about more than Jasper Johns, partly because his work is so very beautiful, partly because it is so mysterious. He seems to have a need to hide behind what he creates, and the viewer can become both awed and mystified. He has deliberately used the familiar and even banal, like targets and flags, shapes everybody knows by heart, and has drawn them, by sheer painterly love, into beauty. There has likewise been a series of maps, all taking as their formal basis the map of northern America. *Map* (1962) is one of the most austere of these images, a great, sober, yet exhilarating expanse of subtlest blue-greys. The various states keep roughly their shapes, often confined by ruler-straight lines, and a great variety of stencils gives them their names. Individual letters shine out at us: a free, pure 'A' in Virginia, the rough brevity of 'NEB', Nebraska, or a black 'Texas', small against a white rewriting of the word. Names and forms drift in and out of focus, suggesting the unfathomable reality of a continent. The titles of the bordering oceans continue off the canvas, out into infinity, since no country can be encapsulated in its own isolationism. We all share a world, but a world we cannot understand. At the lower edge, the map dissolves into a tattered gold, as if there were another reality, even deeper than what we see, even more lovely, more real. And as we look, we see that gleams of a secret, hidden brightness shine through all over the image. Swirls of dark clouds may move in from either side, but the picture grows more luminous towards the centre, as if defying the outer darkness. The small states, with their blazoned names, take on a touching bravery, maintaining their identity, despite its frailness, in the presence of so much that is unknown and seemingly threatening. There is an inner confidence, a sort of love for the map in all its imperfections, which affirms that the threat, however experienced, is in truth only 'seeming'. We may never, in this life, fully understand our world or even ourselves, who are so intimately related to it; but God understands, and loves His world and His creatures.

Encaustic and collage on canvas
60 × 93 inches

Ken Kiff

Flower and Black Sky (1987–88)

Here, pre-eminently, is a picture to be contemplated rather than discussed. It scarcely seems to have made it into material existence. One side of the paper is ragged and torn, and the edges wobble as if under the pressure of Ken Kiff's emotion. (His art often shows volcanoes and raging seas, symbols of the mad chaos of the human psyche.) In *Flower and Black Sky* the flower stands alone in a lifeless landscape. To the right is a skeletal tree, pale green like an enlarged branch of seaweed, waving its dead branches despairingly in all directions, and in vain. To the left, low in the black sky, the sun is visible, and yet it gives no light. It is a sun of faith, a willed sun, overpowered by the darkness and still holding its place, waiting, keeping faith in powerlessness. The small flower is not dismayed. In an unmistakably anthropomorphic gesture, it raises its leaf-hands in prayer, it raises its flower-head in trust. The praying hands do not implore, but seem rather to jubilate. Incredibly, the flower almost orchestrates a hymn of jubilation. Like a conductor, the leaves rise to summon invisible players and singers. However black the sky, the flower is totally assured of life's essential joy. Silently, as it lifts up those hopeful leaves, it appears to draw into being a cloud of luminous vapour. Only where the flower is, in the presence of its trustful prayer, is the radiance apparent. Perhaps Kiff is suggesting to us, implicitly, that there can never be total darkness for a believing heart. Out of nothing, light will arise, almost of its own accord. The darker the background, the brighter shines the faith and hope of the believing heart. The drearier the prospect, the more it generates an inner light. It calls on a strength not its own, while a far stronger creature, the tree, has succumbed to the enveloping night. No, the flower, the faithful who stakes his or her all on God's faithfulness, is at peace and in joy because prayer gives us the certainty of God's love. He loves us not because we deserve love, but because He *is* love. With that as our happiness, we can live confidently under a darkened sky and in a desolate universe.

Watercolour 7
x 17 ¼ inches

74

Paul Klee

Red Balloon (1922)

In 1918 the German war machine was running down, and Klee, in his deliberate fashion, spent his time as an army clerk, writing his 'Creative Credo'. Of one thing he was certain, that art 'should know how to deal in good and evil, like the Almighty'. This has a weighty sound, yet no artist has ever dealt more gracefully with these grave matters than Klee. *Red Balloon* could almost seem abstract in its playfulness, until we realize that the glowing rectangles are doors and balconies, the soaring triangles roofs, and the dome on the left holds an exuberant tree and is a huge greenhouse. Central to it all is the radiant red balloon. The sheer beauty of the colour already makes it clear to us that this is not a realist picture. The balloon is like a sun come down into our world, setting it alight with its own rich splendour. Is it coming down to us, or going up? An Incarnation or an Ascension? Either way, it is ours. It belongs here below, though it is not earth-bound. The picture abounds in verticals, straight true lines that still do not touch the edges of the canvas, but hover in their own space, as it were. They all repeat and re-emphasize the slender rope that hangs from the balloon, its tip a small ball so that we may grasp hold of it. Would this be to lift us up? Or would it bring the balloon more completely within our sphere? Great poet that he is, Klee offers us both possibilities. In this he is pondering the human condition, our painful duality of being. He described it as 'a dichotomy . . . this simultaneous helplessness of the body and the mobility of the spirit'. But for Klee, art is profoundly redemptive. Here, in *Red Balloon*, the gulf sundering the eager spirit and the weak earthly body is healed, dissolved, transformed into blissful unity. The bright hovering balloon makes all its context bright through its presence. The spirit, (the Holy Spirit), has become the visible core of a city street, setting free all the potential for colour and joy that is secretly inherent. Klee changes nothing, he simply allows the balloon to reveal to us the wonder of pure being.

Oil (and oil transfer drawing?) on chalk-primed gauze mounted on board
12½ × 12¼ inches

Willem De Kooning

Door to the River (1960)

Willem De Kooning described Mondrian as 'that great, merciless artist . . . the only one who had nothing left over'. Though the remote and passionless geometries of Mondrian might seem alien to De Kooning's surging abstractions, for both artists, art was 'a way of living'. De Kooning gave himself to his work with the same absoluteness as had Mondrian, but his way of 'having nothing left over' was to mean an exposure to the actual, rather than to the ideal. *Door to the River* does not explicitly depict cliffs, woods and river, but it makes one feel what these things are like. It is bathed in sunlight, in the spaciousness of distance, in the exhilaration of the countryside. It is a 'door' to the river, and it allures us to 'go through', to open the door and enter into an unknown landscape. There is even a subliminal suggestion of a narrow door, an entry into a personal challenge. We can accept any challenge solely because the radiant beauty of the work assures us in advance that we are 'safe'. Talking about this kind of abstract-figuration, De Kooning has referred to 'content'. He calls it 'a glimpse of something, an encounter like a flash. It's very tiny, very tiny, content.' His point is that it does not need to be large, to force itself upon our attention. It is simply there, giving the picture its weight. Although he tends to shun any but the most down-to-earth language, De Kooning is clearly entering through his art into a sacred freedom, where limitations can be seen as liberations. The actual world in all its lovely complexity is the sign of a divine Presence. We do not need to see the forms of the spiritual reality to be aware of its all-pervading light. Historically the 'river' is in New York, yet it announces itself as 'the River of Life', and the whole picture plane is alive with the great, strong movements of infinitely gentle paint. There is a tenderness in its strength that again recalls the biblical door that opens to anyone who knocks. In prayer, to be at the door is to be through the door: to have sought is to have found. We may not know where God has taken us, only that he has taken us, and that 'it is good for us to be here'. There is only a door to the River, never one from it.

Oil on canvas
80 ×
70 inches

Leon Kossoff

Here Comes the Diesel, Early Summer (1987)

Père de Caussade, a seventeenth century Jesuit, based his mystical teaching on what he called 'the sacrament of the present moment'. It is both the simplest and most difficult of beliefs, demanding that we attend with an absolute reverence to the actual world around us. If we do not see God there, we can only find Him faintly in our 'spiritual' times. It is this 'sacrament' that makes the work of Leon Kossoff so overwhelming. Nothing could be less romantic or seemingly mystical than the unique stridency of the Diesel train, strident to both eye and ear, juddering its active way through the outskirts of London. Kossoff's picture of it, squat amidst the turbulence of early summer, can make us catch our breath with wonder. London itself, in all its civic grime, is frequently the subject of Kossoff's meditations. He has spoken of being driven by 'an urgency' that comes not only from 'the pressure of the accumulation of memories and the unique quality of the subject on this particular day', but also from 'the awareness that time is short'. The present moment is only for now: either we see it as the revelation of God, or we have lost it for ever. Once we do see, as Kossoff does here, the memory becomes part of us, and the present, now gone into the past, remains into the future, changing its nature. We shall see the next 'present moment' with deeper understanding because we have seen this one. The wonder with which Kossoff celebrated the small train, set in its unremarkable landscape, inspires wonder in the viewer. The grasses quiver with the summer warmth, and the ordinary brick building across the tracks, with its two swaying poplars balancing the two fence poles on the nearside, is luminescent with the flickering sun and shadow. The artist speaks of 'the shuddering feel of the sprawling city', and how it can linger in his mind 'like a faintly glimmering memory of a long-forgotten, perhaps never experienced childhood which, if rediscovered and illuminated, would ameliorate the pain of the present'. In a strange fashion, truly seeing the present, whatever its pain or its dullness, (its Diesel quality), at once sets it in a context, a numinous context, an awareness of some holy meaning.

Oil on
board
54 × 48
inches

Catherine Lee

Isis (1988)

In reproduction, Catherine Lee's work looks large and imposing. It is imposing enough, seen face-to-face, but very far from large. *Isis* is barely 16 inches high, and yet its presence is majestic. Lee's work dominates any wall on which it hangs, solely because of its innate dignity. Yet it is not only in its dignity, its great presence, that *Isis* affects us. Equally, if not even more so, it is in its pathos. If Isis were a divinity, one belonging to a cult of immense antiquity, it would be a cult that has for ever passed away. Milton, in his great ode in celebration of Christ's nativity, sings movingly of the pagan religions, so sacred to their worshippers, and now dismissed as empty superstition. Something, he reluctantly hints, may have been lost. *Isis* gleams with an exquisite dappling of patina, greeny-gold, cream and white; its irregular rectangle-oval (neither is accurate) is banded by a sloping sash, slate-coloured and clouded. The sash jerks upwards in the centre, where the golden-green inserts itself, and we see that the whole piece is composed of sections, four light-patinated, one dark. Lee makes no attempt to fit the sections neatly together. They adhere, but loosely, lightly, unprotected against a possible dissolution under pressure. In all its regal beauty, *Isis* bears the stigma of disunity. Yet – here is the central paradox – this disunity, this fragile clinging together of diversity, is more a homage to oneness than any careless block of unsundered substance. *Isis* achieves a unity, wins through to what is not naturally given, concentrates on keeping close to a disparate piece of fellow-bronze. Underneath the lovely graciousness of Lee's work is this strong, brave assertion of the need to join together what circumstance has sundered, and in the joining, not repair a broken beauty, but create a wholly new one, a deeper one, the beauty that fallen humanity can most respond to from its own suffering experience. Lee has expressed her admiration for both Matisse and Brancusi, two great artists in accepting the reality of their human context and from that context shaping extraordinary grace. Being fragmented is not an obstacle to the Holy, but, here on earth, the condition for it.

Cast bronze
with
patination,
unique
16 × 7⅞ ×
1½ inches

Kim Lim

Wind-Stone (1989)

When the Greeks mythologized their world, they were expressing poetically what we all know by instinct: 'The Lord is in this place and I knew it not.' The natural world as it is given to us, in contradistinction to the technological world that we have erected for ourselves, has an unforced holiness that speaks to us silently of God. Some art enters very deeply into this silent communion, art therefore difficult to discuss but very open to experience. Kim Lim is such an artist. She hardly seems to 'make' art at all. It is almost as if she finds her forms there in the stone, needing only her perception, her love, to reveal them to others. *Wind-Stone* has this pure, quiet simplicity. The marble is Rose Aurora, most delicately tinted with the pallors of the early morning sky, and it stands upon an earth of Portland stone. Neither is fussed into activity. The base is as still and severe as its privilege to be base asks of it. The gentle grey of its block holds up to the sunlight the carved sheen of the marble. It is not a glossy sheen, and retains its natural roughnesses, but the movement on its sides and over its form is that of the wind. Wind, we know, does indeed shape our earth. Like water, it imperceptibly changes shapes, carving them by its unseen pressures. *Wind-Stone* has the profound rightness of form that such natural pressure creates. A great wave of curve rises on one side of the sculpture, and the wind subsides into a hollow, receptively, on the other. Into the deep clefts the wind has (apparently) made, light and shadow play, altering what we see as the daylight changes. The Latin word for 'wind' is 'Spiritus', which also means 'breath', all concepts alive in our word for the creative God, the Spirit who moved over the waters and gave order to our primeval chaos. The mystery of the wind, always unseen except in its effects, is one on which generations of human beings have meditated. That our God too is a Wind, and that He is a Breath, our breath, our life-giver, touches us to the core. All these expressions of our creative closeness to God, our need of Him as inspirer, (breath-infuser), are somehow communicated to us in the unhurried graciousness of this Stone formed by the Spirit, this Wind working with love upon the human Stone.

Rose Aurora
marble 38 ¼ x
27 ¾ x 11 ½
inches

Morris Louis

. .

Alpha-Phi (1961)

Alpha-Phi is an enormous picture, eight and a half feet high, and fifteen feet long. The title is simply the Greek letters that Louis's widow gave his works to distinguish between them. Morris Louis, a quiet, withdrawn man, produced three magnificent series: the Veils, in which he poured out great waves of colour over a canvas, like a waterfall; the Unfurleds, (of which *Alpha-Phi* is one); and the Stripes, where long lines of colour speed from one edge, arrowing with undeviated precision. This passionate directedness is characteristic of Louis. Once he had discovered that he did not need to apply paint with a brush, but rather to let it stain into the actual support, he embarked upon an intensity of creative action that lasted until his premature death. The pictures in the Unfurled series confront us with an almost empty canvas. The great centre offers itself to the viewer completely bare: all the colour, all the work, is at the extreme edges, where bright rivulets of pure paint have been dribbled down in separate streaks. How Louis achieved this remains unknown, and he insisted on working in secret. One suspects that many Unfurleds failed to work, with all the horrendous possibilities of smudgings or of colours that did not combine into the daring harmonies that Louis sought. Those that remain are all works of extraordinary power. The power is contained both in the central emptiness and in the challenge to our continual human need to make an image into a unity. But we cannot hold in our gaze both sides of *Alpha-Phi*, it is too large. If we turn to look at the right, we must accept that we cannot see the left, and vice versa. The work refuses to be contained, refuses to allow us to dominate it. Rather, the domination is its own, forcing us to face up to the challenge of that vast space at its centre. If in prayer we have to leave behind our desire to comprehend the greatness of God, acknowledging that it is He who must comprehend us, then we can see why a great Louis draws us into a contemplative experience. We are taken out of the ego into God's vastness. Yet there is a lifeline to the material world, those dazzling sidestains of intense chromatic beauty. We can receive the joy of the beauty only if we also receive the bewilderment of the nothingness at its core. One experience validates the other.

Acrylic on
canvas
102½ ×
177 inches

Brice Marden

Untitled No.3 (1986–87)

Brice Marden has said of the painter that 'he works to keep man's spirit alive'. Painting is a sacred task; it is not play, not recreation, but a serious and responsible work. Looking at the free, uncluttered beauty of *Untitled No. 3* it is difficult to understand this almost painfully serious view of what a work of art is and does. But Marden is adamant. 'Painters', he insists, 'are among the priests – worker priests of the cult of man – searching to understand but never to know.' This distinction between 'understanding' and 'knowing' helps us to become receptive to *Untitled No. 3*. It does not seek for anything as definite or as limited as knowledge. Knowledge can be encapsulated, passed on from one to another in a neat bundle. But understanding is limitless. We cannot give it to anybody, not even to ourselves. All we can do is search for it, as Marden does, with careful labour and with love. This painting is supremely one of love's labour. He uses only the simple colours of nature: red and green, those vigorous opponents; black and white, those emphasizers of each other. His marks circle back and forth, shadow upon shadow, always suggesting that there is greater depth beneath, past experience overlaid, a richness of perceived texture. Out of the seemingly effortless tracings of his paint he creates this delicate trellis, with its misty heart. Nothing here shines or demands attention, all drifts lazily to and fro as if blown by the wind. Yet this lovely grace tells us that it is a wind from heaven, the breath of the Spirit. If he is a worker priest, then what Marden works at is sacramental. Yet, again, there is nothing to get hold of to prove the presence of the sacrament. We have to do what all worshippers must do: we have to be still and let God speak in the encounter. If we do the speaking, it can only be 'knowledge', exercising the mind. But if we allow God to speak through the gentle power of *Untitled No. 3*, then we can enter into 'understanding'. Marden writes about 'the edge, the balancing point . . . the infinitesimal hinge between'. It is to that in-between place, where we can swing out of our own crude bodiliness into a purity given to those who long for it, that an artist such as Marden can invite us.

Oil on linen
72 × 58 inches

88

Walter De Maria

Lightning Field (1977)

Earth Art, of which Walter De Maria's *Lightning Field* is one of the finest examples, demands, of course, to be experienced. It is almost an aristocratic relation of Performance Art, in which there can be no art at all unless the viewers share and co-operate. But we can still use our imaginations, taking photography as a jumping-off ground to enable us to experience, as at a distance, the wonder of art actually formed out of the earth and only fully available to those who take the time and trouble to venture out into its locality. *Lightning Field* stands in flat semi-desert in New Mexico, rimmed around with mountains, so distant, so inaccessible, that those who want to see it must make a pilgrimage there and take a long walk through the sands to see it in its totality. There are 400 stainless steel poles, over twenty feet high, arranged in a grid, rigorously regimented. It is an area of storms, and De Maria intended his poles to attract the splendour and visual magnificence of the lightning, yet he also knew that even in these optimum conditions, very few visitors would actually see the wild blaze strike down onto the expectant grid of poles. Every visitor takes a chance: the 'art' is in this willingness to experience. It is also, even more so perhaps, in the willingness to see the poles, gleaming in the windless heat of the desert, as beautiful in themselves, intrinsically beautiful. De Maria has told us that part of the 'essential content of the work is the ratio of people to space: a small number of people to a large amount of space'. This fundamental loneliness, which we can only share imaginatively through the reproduction, is immediately comprehensible as an analogue of the loneliness of prayer. Since, too, the lightning is rarely seen bodily, but is believed in, is the secret reason for the work, ('The invisible is real', says De Maria), the parallel becomes even closer. There have been intricate mathematics and hard physical labour to enable this work to exist. Its existence is a silent acceptance of our incapacity in the face of nature's power and our faith in its wonder. As we prepare for our encounters with God, we also painfully construct our grids of good intent, and wait with loving confidence for Him to make of us His 'Lightning Field'.

400 custom made stainless steel poles with solid pointed tips 1 mile x 1 kilometre

Agnes Martin

Untitled 9 (1990)

Agnes Martin's work is very difficult to write about. She is herself, in the natural poetry of her spoken word, the best commentator, yet she has rarely ventured on any specifics. What she has made clear, though, is that she disagrees with landscape interpretations. As a child of the Canadian prairies, and as one choosing now to live in the desert vastness of New Mexico, Martin has frequently been thought to represent, albeit in the most abstract fashion, those limitless expanses of sea and sky. They obviously do affect her, and she has spoken of the rapture that fills her when she contemplates the horizontal line, but it is an innate horizontal, as it were, one that comes from a moral passion, not one suggested to her from without. Nothing in her work comes from a within/without dichotomy. She is a unity so pure, so painfully achieved and so ecstatically surrendered to when arrived at, that the viewer feels abashed. It is inevitable that her work resists the glibness of commentary. What is there to take hold of and dilate upon? And just as books on prayer may be harmful, giving the reader the sense that to read them is to pray, (whereas they must be laid aside and the task surrendered to in responsible loneliness), so with commentaries on art. We do not see unless we see for ourselves. To see truly takes time and it takes patience. Martin has spoken of people going to the sea and watching it all day. That kind of simple attentiveness is what her painting requires. It is, somehow, not there, not what it really is, until we have sat peacefully before it, contemplating. 'There's absolutely no hint of anything in this world, any object, in my painting', she tells us comfortingly, 'so that's a nice rest.' But there is enormous content in these 'empty' paintings, content that only silence can disclose to the individual viewer. The pure, austere peace of *Untitled 9* draws us into an encounter with the Numinous, with the Invisible One, with our own untruth and non-peace. We rest within it, taken into a divine quietness that is ours for the desiring. Martin has admitted that these latest works are 'all about Praise'.

Watercolour on paper 9 x 9 inches

Henri Matisse

The Snail (1953)

If not Picasso, then Henri Matisse is the one unqualifiedly great artist of our century. Even if he had died young, his work would remain unique: from the very beginning, it possessed a profoundly intelligent beauty that has an enormous power of concentration. This power deepened as he aged, and the old Matisse, bed-ridden and in pain, achieved a new kind of art. Unable any longer to wield the brush, he had his assistants prepare great sheets of coloured paper, from which, using his scissors like a sculptor's tool, he cut out the tremendous images that filled his heart. This work has a completely unhampered freedom. He told a friend that, before his illness, he had 'always had the feeling of too much effort . . . I always lived with my belt tightened. What I created afterwards represents me myself: free and detached.' This new freedom, this escape from the chains of his ego and its anxieties, enabled him to attain what he described as 'form filtered to the essentials'. His first attempt to draw a snail entailed holding the creature in one hand and repeatedly drawing its natural shape, until he became 'aware of an unfolding'. He saw in his mind 'a purified sign for a shell'. The final work is huge, well over nine feet high and almost a perfect square; it dominates its wall at the Tate Gallery. The great pure rectangles of intense colour curve round in a stately movement, the nearest Matisse ever came to abstraction. He has entered by imagination into the wonder of this lowly mollusc, not literally protected by a spirally brightness, but spiritually. There is a powerful gravity in the great shapes as they surge inwards, ever diminishing their circle until they reach the centre. They seem both still and in gracious flow, suggesting the stealth with which the snail journeys and the protective carapace within which it can, if threatened, always wait out danger. This sense of the constant availability of protection seems to have drawn Matisse to the image, and it draws us too. Safety, and with it freedom; the world obeying the gracious solemnities of the dance; all these precious nobilities are offered us in *The Snail*. The great gleaming whiteness of the background is the necessary condition for the controlled explosion of colour to unfurl and move forward.

Gouache on
paper
821⅜ × 821½
inches

Garry Fabian Miller

Bluebell May 7th 1989 (1989)

Garry Fabian Miller has a deep reverence for nature, that innocent actuality within which we all live, but which we ignore and, to our mutual detriment, misuse. The great things of nature can overwhelm us: Miller chooses rather to look with eager love at the small things, the leaves, the plants, the flowers. His art is essentially this looking, the long, intent, contemplative gaze, in close communion with the mysterious life that reveals to us the meaning, or potential meaning of our own lives. 'Time and closeness offer hope', he has written. Unless we give the time, unless we come close, we have no access to this transformative 'hope'. Miller does not paint nature, he does not draw, he does not use a camera. For his first looking, he wishes to 'go out unarmed'. What he does is to bring home with him the leaf or flower that this contemplation has seen as revelation, that has been for him 'one of those moments . . . of feeling more keenly the pulse of creation'. In *Bluebell May 7th 1989* he has taken the tiny filament of a bluebell stamen, magnified it in his projector onto light-sensitive paper, and so made 'a living fossil'. We see not the bluebell itself, that easily appreciated (and easily forgotten) flower, but the stamen, the tiny and almost invisible centre of the flowerhead. Looked at like this, with the magnifying eye of love, this fragile thread of tissue appears as a flower in its own right. The infinitesimal slenderness of the stalk sways upwards with a graceful curve, the stamen-tip burns with a delicate purple, like a flame on a taper. The sense of aspiration, of a reaching upwards and outwards, is very moving. Miller believes that when 'we look at art, we somehow seek to allow its aura to work on us, slowing down the pace of our perception'. He speaks of the offer of 'clear water within the turbulent stream of our existence'. Miller is explicitly referring to cathedrals, before widening his argument, but the wonder of his art is to become a 'cathedral' for the viewer. In his tender, humble, bravely ascending *Bluebell* we come miraculously close to the holy wellsprings of Being. Like Julian of Norwich's hazelnut, the whole creation seems to be *Bluebell*, held lovingly in God's hand.

Flower, light
and
cibachrome
20 × 10 inches

Joan Mitchell

Two Sunflowers (1980)

Joan Mitchell might be considered an abstract artist for the all-overness of her work, yet she is so profoundly aware of nature, of earth, leaf and flower, that it is abstract only in a poetic sense. We cannot here 'see' the two sunflowers of the title, yet they are physically very present. That richly glowing gold, that supportive virginal green, those squiggles of black: all are 'sunflower' in their colour, all are somehow directed upwards, as the flower is. The sunflower is a proud, tall radiance which we experience as a life-form that gives rather than takes. It does not only seek the sun, it acts like it, raying out petals from an intense centre and offering its brightness to those who approach. All these delicate qualities Mitchell makes present to us in this painting. Yet we would not know that this is *Two Sunflowers* had we not been given the title. The actual canvas is an intricate mesh of colour and line: an abstraction. Given the name, we can read it, with joy. This is surely part of the delight of the work, that we have to be still before it, let it reveal itself to us, before we can 'see'. This is a parallel of what happens in prayer. We have the words of our faith, we may know its concept and its teachings, but we may not see the quick-moving blur of our lives, as actually lived, being a revelation or even container of those spiritual truths. Yet all that God has given us is truly present in the actuality of our day. This is how God comes, the only way He can in fact come, first in the Eucharist, then in prayer, then throughout the day. In prayer we can be still and allow the jumbled pattern of our lives, not to unravel into clear shapes, but to reveal in the very jumble that God is present. And he is present above all as Sun. His radiance, His life-giving warmth within all that we are and do, not just to be Sun for us ourselves, but to make us His sunflower, His visible sign to others of what love means. First, though, we have to see how and where this is happening, and prayer both readies us to be alert and generous during the day, and also holds us exposed to Its Presence in Itself. In His light we see Light, and become Light.

Oil on canvas
43¼ ×
60 inches

Piet Mondrian

Composition with Red, Yellow and Blue (1921)

An artist friend who went to visit Piet Mondrian shortly after this work was painted, says that he 'blurted out to him: "It's always as if I am being admitted to the Lord's house when I visit you".' He adds that they both laughed heartily, and that Mondrian told him a young French woman had recently called his house 'a place where there cannot be anger'. Mondrian was the most absolute of idealists, and he set himself to live and work in a setting similar to that of his work. All was rectangular, austere, severely ordered. Since he considered only red, yellow and blue to be 'pure' colours, they were the only ones he allowed himself, and he accepted as forms only the God-given immensities of the utterly vertical and the utterly horizontal. All was to be totally controlled, all angles regular, all spaces at rest within themselves. No artist but Mondrian, who lived this severity, who spiritually needed it, would have taken such a potential impoverishment of artistic grandeur and made it so beautiful. It is an art that takes its being from morality. The world as we know it through daily experience is confused and uncontrollable. Many artists make their art out of the pain of accepting this (Francis Bacon, say, or Georg Baselitz). But Mondrian refused to accept appearances as reality. The real world, for him, was the world of geometric certainties. 'All appearance changes, everything moves, everything flows.' But we must change 'the moments of contemplation into one moment, into permanent contemplation . . . Art must depict the general.' It is these general laws, upright, true, immutable, and hence independent of appearances, that ravished Mondrian. He was convinced that to depict them in their peaceful strength would be a source of inward joy for humanity. His compositions, like this one, are perfectly balanced from within. The pure deep colours make no emotional demands: they open themselves to us to be seen. The thick encompassing lines carefully stop short of the edge, as if acknowledging freedom, while proclaiming that only in order and dignity can we be free. Small rectangles of red, yellow and dark blue carry a weight out of proportion to their size, yet deeply satisfying to our intellectual appreciation of beauty. Experiencing order, we long to be orderly ourselves, to be, like Mondrian, 'the Lord's house'.

Oil on canvas
31 × 19 5/8
inches

Berthe Kaline Naparrula

Wirrimanu (Naparrula's Country) (1988)

There are two ways in which we can respond to the art of a culture that is not our own. One is to abstract it from its original context and simply regard it as 'art'. *Wirrimanu* then appears to us as a powerful and orderly patterning, where rich and subtle variations of colour and form are united into a strong, beautiful statement. As in all abstract art, the meaning of that statement cannot be explicitly verbalised, though there is a deep emotional reaction. We have been addressed at some level that is normally closed to the conscious mind. We can look, and go on looking. We feel in touch with Meaning rather than with meaning. But this reaction, real though it is, can seem insensitive when we consider that, put back into its true context, *Wirrimanu* is a sacred container of immense spiritual significance to its creator and the society for which she created it. In fact, Berthe Kaline Naparrula would claim that she is not the creator, not an artist in our secular sense, but more a vehicle for the eternal to make its constant presence visible. The painting is always somehow there: the artist brings it into material sight. There is no word for 'artist' in Aboriginal culture: there is priestly work that involves the making of art, and this art never exists of itself, still less for itself. It is intimately bound up with the sacred songs by which the Aborigines transmit their history and fundamental beliefs, and all visual art is a part of this ritualized cherishing. Every Aborigine belongs to a definite Dreaming: the Dreamings are sacred personages, yet the people to whom they belong enter into them in their celebrations. They are based upon places, the real material earth of Australia (like Wirrimanu). 'My father said this', explained an Aboriginal artist: "Look, your Dreaming is there; it is a big thing; you never let it go . . .".' The artist continued: 'Something is there, we do not know what. Something . . . like engine, like power, plenty of power, it does hard work, it pushes.' Clearly, even from this faltering attempt to explain the mystery, we are in the presence of numinous power, that which actively affects humanity. We must admit our inability to receive the fulness of grace that the Aboriginal believer can find in *Wirrimanu*. We are being privileged to see the map of where the sacred is. 'I am hunting for lost pieces of myself', said the artist. If we look with humility, we too may find our search rewarded.

Acrylic on
canvas
24 × 36 inches

Robert Natkin

. .

God's Way (1988–90)

Robert Natkin, a great lover of Hitchcock's films and the poetics of the theatre, often gives seemingly mundane titles to his works, but they are all really concerned with *God's Way*. He has spoken of the painful need to disengage himself 'from the security of the known'. He is convinced that, as an artist, he must 'exercise and exorcise myself to exist in what I call the abyss . . . a very uncomfortable word'. He adds wryly, 'The blank canvas is certainly the abyss. But so is the finished work if experienced on a certain level of faith, of risk.' *God's Way* enters into this 'abyss'. It is nearly eight feet high, a vast multi-layered expanse of evanescent colour. It hovers before us, scarcely there at all, yet powerful enough to hold one motionless before its mystery. It is 'the abyss' in that it offers no slick certainties. What it means or what it reveals of the ways of God cannot be conceptualized. Natkin, whose wit delights in wordplay, has said that 'We are each alone – we are each a loan'. We are lent by the Divine to ourselves, to be used and made use of for others. The necessary condition for this is a state of spiritual solitude. We have to accept being taken out of our own safe limits into a holy Otherness. What this means Natkin does not 'know', but he shows it in *God's Way*. It is not, by definition, *our* way, the comfortable human way that we know how to manipulate and circumvent. If the artist lives in the painful loneliness of inner truth, then s/he is admitted to 'God's Way', which follows a sacred logic of its own. All the artist can do is follow, and in this, open up the 'Way' to the viewer. When Natkin admits he wants his works 'to show as much as they hide and hide as much as they show', he is inviting us to venture with him out of this comprehensible buying-and-selling world into one where Beauty is all that matters. Clement Greenberg, the great American critic, once told Natkin he was 'excessive'. Natkin retorted that he wanted to be 'accessive'. The word is not in the dictionary, but we know what he means. *God's Way* offers 'access' to the Mystery, if we are prepared to pay the price of silence and to enter its serenity, where our independence becomes a 'loan', and we are blessedly not our own.

Acrylic on
canvas
96 ×
88 inches

Odd Nerdrum

Revier (1985–86)

Odd Nerdrum is an artist deeply conscious of our contemporary poverty. He seeks in his art to be what he calls 'an historical anarchist', one who will not conform. 'To be in my own time is too poor a thing', he thinks. 'My time lacks too much and I will be cheated and cheated and cheated. My time shall not direct my feelings for the truth.' It is not that Nerdrum retreats to past times, though his strange people may suggest prehistory to us. To him they come from a no-time, an era of the free imagination, where they can therefore make visible to us 'the truth'. This truth is a painful one. Nerdrum sees the essential human condition as one of agonized longing, of need, of insufficiency – and of confused unknowing. *Revier* is an image of magnetic force. Shaven-headed, wrapped in an animal skin, the lone watchman holds a modern gun with one hand and a long staff in the other. He sits on the curving top of the world, it appears, with barren pebbles stretching around him in all directions. He has semi-fashioned a throne, and all around him he has ranged the largest stones on view; are they a protective ring, the nearest he can come to the support of a laager? Or has he been imprisoned in this sacred circle? Is he free to get up and go? We note that one foot seems to be wounded, tied up with elaborate care. We note too that he has by his side either a tightly knotted stone or a stone-like bag: otherwise he is bereft. Yet he watches, he is intent. Nerdrum thrusts the foreground stones in our faces, keeping the warrior in the shade. He vaguely resembles a bronze Buddha, except for the intrusive and frightening weapon. And his title: does it refer to seeing again, or living again, or even to dreaming, in a reverie? We spend far more time, and with profit, pondering the secret than we would if the title were intelligible. Nerdrum forces us to enter imaginatively into this lonely and hostile emptiness. We recognize it: it is the human heart, centred on itself, armed against attack, desperately needy, blocking out reality. The sky turns the most delicate of hues, and the watchful man stares straight ahead. What is he watching for, we ask? But we already know: aware or unaware, he watches for God, and the skies tell us God is coming.

Oil on canvas
63 ×
77 inches

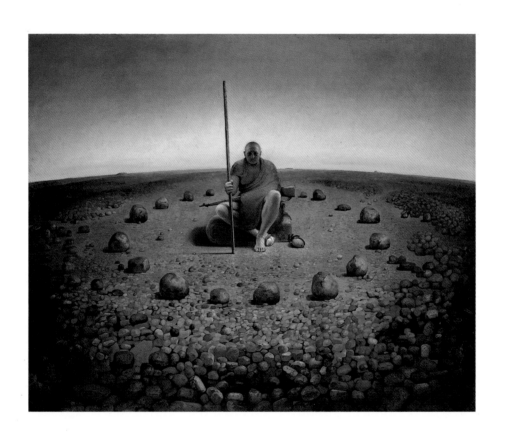

Margaret Neve

Trees of Gold (1989)

As a child, Margaret Neve lived in Wales, amongst sheep, and these gentle, placid animals have remained in her art as a symbol of some sort of eternal innocence. They are omnipresent; there at the Fall of Adam and Eve and blissfully unconcerned, there at the angelic jubilee over the birth of Christ, equally undisturbed by the need for salvation. The sheep, in their Scriptural innocence, Neve hints, are what we are called to resemble. In *Trees of Gold* they file through the world as we would like it to be. All is rich and all is disciplined. Grass grows with sweet regularity: no call for the violence of the mower. Trees rise and swell into close-packed leafy fullness, never a twig disobedient to the pattern, and bushes, hills, forests, roll back to the heavenly order of the sky, all co-operating with some secret harmony. At the very top of this orderly world stands an angel, blessing. Golden droplets stream from his uplifted arms, a passageway to the angelic world above. We see it, but – and here is Neve's point – the sheep do not. Golden trees and blessing angels, these are beyond the understanding of animal docility. It is we, the wild and disorderly ones, who can see what is happening and respond. Neve uses a demanding technique for her work, multitudinous dots, each a tiny glimmer of brightness, each able to be seen as separate or as blended, according to our position. Like the tightly budded trees, the Seurat-like dots have a cumulative significance. This radiant world of interior order, with its promise of a path to a heavenly angelic world, is achieved through labour. Neve prays her work into existence, into holy meaning, by hour after hour of fine-tuned flicking with the most delicate of brushes. Hour after hour, day after day, she summons into visibility her mystic sheep and the world they offer to share with us. If the work takes long to paint, it equally takes long to view. Only after contemplative attention may we notice that the trees are not uniform. The nearest trees, the trees on our side, as it were, are closed. But the distant trees, the trees on the angelic side, are opening. Their branches stretch upward like imploring hands, and the golden haze of blessings rests upon them, unsecured. The 'meaning' is in the experience, in the longing for God it awakens.

Oil on wood
panel
23½ ×
20 inches

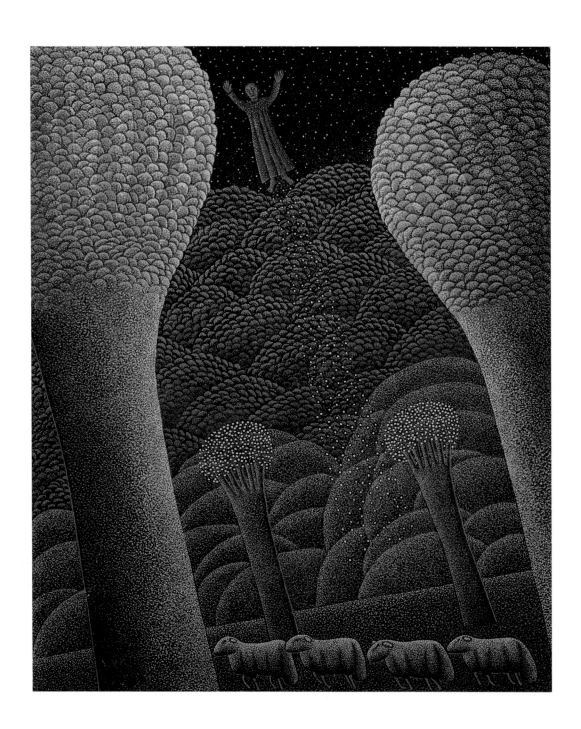

Winifred Nicholson

......................................

Hebridean Roses, Eigg (May 1980)

The first painting Winifred Nicholson felt was truly hers – she called it a 'flowering point' – was of flowers on a windowsill, light and colour dissolving into each other and the great world outside made one with the small world within. At an even deeper level, with more profound awareness and increasing spiritual freedom, this is the picture she essentially painted for the next sixty years. The theme was infinite. She speaks of 'colour-light – so that the picture becomes a lamp – a luminosity – a transparent entity'. What she actually saw and shared with the viewer was only a way through to what was not literally seen and yet experienced. She tried to explain it in words, calling it 'a relationship of abstract space shapes'. When the artist found this blessed relationship, it became 'the point where painting touches "spiritual reality" – the fundamental essence of things, beneath, behind, beyond and before visual experience'. Yet, paradoxically, one could only get to this reality through a reverent attentiveness to the visual, and it is this dual attentiveness that gives what could seem simple flower pictures their wonderful and transforming power. *Hebridean Roses, Eigg* was painted in the May before she died. Each insignificant wild flower has been lovingly contemplated, from the wild roses of the title to the frail spotted orchid, the bluebells and the tough little ferns from the hill beside her cottage. She painted them on an early morning in May, set as ever on her windowsill, the waters and mountains of the Isles shimmering in the mist beyond. The outside world provides the humble jar with the appropriate setting. Slight and fragile, the glass concentrates within itself the radiance of the spectrum, making the Eternal 'at home', internalizing the glory of the created universe. Colour had for Nicholson a mystical significance. She called it 'unknown colour', not because we failed to see it in its true power – though that too she held – but because there is more to colour than we can in fact see, however carefully we look. Colour, for her, did not cover shapes, but was somehow between them, on the rim; it was concerned with 'states of being, and being itself'. She draws us into mystery at its humblest, its most accessible, its most contemplative.

Oil on canvas
56 × 45 inches

Jules Olitski

Judith Juice (1965)

Jules Olitski has been called one of the second generation of Abstract Expressionists and, like Rothko and others of the first generation, he was born in Russia. Something of this Slavic intensity seems present in his huge fields of stained colour, at once mysterious and seductively beautiful. We could say that *Judith Juice* is about intensity. We are irresistibly drawn into that great central oblong of profound, radiant, concentrated blue. This radiance is essentially uncrowded. The picture has room to breathe; the intense blueness allows for a shimmering white at its central borders, and it lives in contentment with the equally intense orange on three sides. Not only is there co-existence, but there is that unforced mutual acceptance that makes the colours each more themselves, more totally focused, because of the complementary hue beside them. The blue is what draws from the orange all its capacity for orangeness, the orange makes the blueness total. Intensity – passion – is here because the trained intellect and learned skill of the artist have brought them here. Passion is not wild emotion: it can be deliberate choice. The passion for God that arises from prayer – and which can only arise there, where God takes possession and loves within us – is never a narrowing passion. It does not drive out our other desires, but integrates them and gives them meaning. Because God is all that matters, everything else at last begins to matter as it should. Love becomes universal, not only allowing others their own truth-to-self, but actively helping them to attain it, as the blue and orange do to each other in the painting. Freedom, warmth, a security so vast that it can take all risks and not see them as frightening; all this is the result of an absolute directedness to God and God alone. But it is a passion of directedness that exists in being, not in feeling. *Judith Juice* is not a proclamation, it is an actuality, a painting that one man brought slowly and surely into existence. It is our actions, the life we lead, that make actual the intensity that God silently infuses at prayer. It is not from us, but from Him, just as the work of art is from the artist's paint and energies. Our part is to want to want, to surrender our potential to His Will.

Acrylic on
canvas
98 ×
68 inches

Beverly Pepper

Zig Zag (1967)

Angkor Wat is an immensely complex mass of carved architecture, half ruined, wildly overgrown by the trees and plants of the Cambodian jungle. One would not associate it with a conversion experience. Yet it was precisely in exposure to this chaotic construct that Beverly Pepper received her sculptural vocation. 'I walked into Angkor Wat a painter, and I left a sculptor.' Something in that interwoven mass of tree and crumbled masonry set her free to realize her own very distinctive imagery. Pepper's images can be of gigantic scale, though the monumentality is essentially something of the spirit, of a magnanimity of conception, rather than merely material. *Zig Zag*, though it gives such an impression of grandeur, is not much more than man-sized. But what Pepper has done is to sculpt with space itself. *Zig Zag* incorporates three 'realities'. First there is the massive frame, folding and erect, suspended in its own triumphant power. But this steel frame is polished to a mirror-like clarity, and so – the second reality – reflects back to us, in a dizzying movement, all that lies on every side of it. Barbara Hepworth, the first of the great woman sculptors, loved to set her work out of doors, and the sculpture garden she arranged still exists. Henry Moore also gloried in the challenge, and saw his work complemented by the landscape which it echoes. Few sculptors can rise to this challenge. They can cope with the man-made, the city, but raw nature diminishes them. Not so Pepper. Even more than Hepworth and Moore, she needs the wild surround, not echoed in her work, but reflected, imprisoned, bent to the artist's vision to become an essential part of the whole. And then, having taken earth for her material, Pepper adds a third 'reality', and opens her frame up completely to receive infinite space, the air itself. She has said that, from any angle, 'the voids seem filled and the solids seem empty'. We cannot stand apart from *Zig Zag*, distanced by 'our' environment as opposed to its environment. There is only a majestic unity. 'The abstract language of form that I have chosen', wrote Pepper, 'has become the way to explore an interior life of feeling. I wish to make an object that has a powerful presence but is at the same time inwardly turned.'

Stainless steel and baked enamel 80 x 59 x 65 inches

Pablo Picasso

Girl Before a Mirror (1932)

Pablo Picasso, the proudest and most independent of our century's artists, said that he had 'one and only one master', and that was Cezanne. But what so drew him to Cezanne was not Cezanne's own mastery, but 'his anxiety', which Picasso thought made him of continual interest. This reaction sheds light on Picasso's own art. Although it might seem almost defiantly non-spiritual, he once confided that he saw the great artistic problem as being how to 'get something of the absolute into the frog-pond'. Both were equally real to him, equally vehement in their need to be made visible. Picasso's 'absolute' is specific to himself, an anxious bravado that is present behind a superbly fishpondish mask, but it is the haunting presence of this 'absolute' that makes a work like *Girl Before a Mirror* so profound. The girl herself was a young woman with whom he was in love, and as usual with Picasso, he felt the need both to celebrate this dearly beloved body and to dominate it and twist it into a shape of his own devising. This dualism is everywhere in this work. The girl – Marie-Thérèse Walters – is seen both in herself and in reflection, and 'in herself' she is also doubled, a palely natural profile and a radiant sun of a full face. She is seen both within and without, her body penetrated and played with, both sideways and frontal, and in the mirror, we see her from behind. Youth blooms on the left, it darkens into sorrowing age on the right; golden hair, hanging loose in a hank that radiates its own halo, shrivels into a mysterious shawling; and a swelling pregnant body wisps away to a point. Where is the truth? Do we know who we are? Is the girl clothed or naked, and which image will tell us, left or right? Is there any human mirror that will reveal our being? Picasso subtly hints that there is not, and yet the tone of his work is radiant with hope. That hope is what indicates the hidden Absolute, that mysterious Presence that we call God and Who alone knows the truth of each of us.

Oil on canvas
64 × 51¼
inches

Rebecca Purdum

N.Y.C. 264 (1989)

Rebecca Purdum's works strike one as uttering a great cry of 'YES!' to life. There are two things she rejects. One is what would be, for her, the constriction of a definite image. Somehow, she wants everything, and her repeated images of New York City encompass all the misty swirl of its feeling. This is what a great city can be like, if one accepts, as Purdum does, having to 'work at' our 'own wonderment'. She is not illustrating her feeling: it affects her work, as it must do, but 'it all starts to disappear somehow, and my specific emotions tend to dissolve – what's left afterwards is just the experience of them'. It is this non-specific emotion, entered into so deeply by the artist, that she sets free for the attentive viewer. The other expected element that Purdum rejects is the use of a brush. She finds it intrusive, a tool, and 'I didn't want anything to come between me and the painting.' So she paints with her hands, and we could almost say, with her body. Purdum loses herself in the wonder of her vision, in what her actual engrossment in the working process is going to uncover. *N.Y.C. 264* is as much a revelation to Purdum, we feel, as to us. She has been lost in the floating mystery of the colours and the shapes they impose upon her, drifting in and out of visibility, intensifying here and dimming into a gentleness of faintest colour there. None of *N.Y.C. 264* is legible in the sense of having a relationship to anything outside itself, yet we can be overwhelmed by the 'meaning'. Since it is non-specific, it cannot be verbalized, but this is most certainly an art that opens up to the Holy One. Purdum ventures into these deep waters without map or compass, entrusting herself to her desire for beauty, for truth, for goodness. Only the most intense vigilance can keep her within these unseen areas. It is the risk of all deep prayer: of its nature, we abdicate control, yet it is our prayer and our responsibility. It is we who live the life that here and now we expose to God. He is given the freedom of love, to bless what is truthful within and to purify away what is false. The work is His: God is the One who prays, not we ourselves, but only we can make His prayer actual. Purdum makes visible this most intimate and transforming of acts, of passivities. 'You become the paint, you become the form, you become the structure.'

Oil on canvas
108 × 72
inches

Dorothea Rockburne

The Glory of Doubt, Pascal (1987)

Blaise Pascal was the great religious philosopher of the seventeenth century, a great mathematician, a man who dealt rigorously with ideas and definitions: the supreme intellectual. We can understand what has made Dorothea Rockburne read and reread him from her early schooldays in Canada. Pascal was a philosopher, but was also profoundly religious, a man of prayer, a man who wrung his faith with intensity from the actuality of his own life. A phrase sums up the duality: 'Reason's last step', he says, 'is the recognition that there are an infinite number of things that are beyond it.' Rockburne's art has this same wonderful duality. She is stringently rational, basing her art on mathematical balances, always giving a work its title before she begins, and then concentrating all her being on understanding artistically what she is about. But she is equally a passionate lover of the beautiful, seeking to be lifted beyond cognitive limitations into a purity, an 'ecstasy'. *The Glory of Doubt, Pascal* expresses both these elements: her work is a glory, a radiance of shape and colour, using gold leaf both in its own gleaming right, and as a background, a means of translucence, for her oils. As for the Renaissance painters she loves, the presence of gold, the sacred substance, has an immediate spiritual resonance. But 'glory' by itself could be too emotive. Rockburne does not cry out mindless Hallelujahs. Her art, like Pascal's thinking, experiences a fullness of intelligence and drives it to its uttermost, its 'last step'. Faith is essentially what cannot be proved. Pascal called it 'a wager': we choose to entrust ourselves to an Unknown, and we do so with love and joy. We throw ourselves off balance, out of our mental certainties, in faith. *The Glory of Doubt, Pascal* encompasses precisely this. 'That's why', says Rockburne, 'everything is tipped', (accepting our overthrow by God), 'and yet at the last moment is retrieved', (His greatness holding our trust in security). 'It gives the feeling of an experience', she continues, 'that you can be completely off balance and yet somehow not fall. Instead you move forward.' Rockburne moves us forward out of self and its dimness into the Glory, given only to those who love enough to go deep into a saving doubt.

Watercolour and gold leaf on prepared acetate and watercolour on museum board
44⅞ × 73¾ inches

Mark Rothko

Number 1, White and Red (1962)

During the fifties, Mark Rothko, who said that his great artistic aim was 'clarity', direct communication to the viewer, found his way to this very demanding ideal. This 'clarity' was to offer something of 'the poignancy of music and poetry', an art essentially of 'content', where emotion, sublime and tragic, could be shared and a human ennoblement effected. Rothko began to paint very large canvasses, staining deep into their texture great floating rectangles of subtlest colour. The colour seemed to float before one's eyes, feathery and insubstantial, yet enormously potent. At the beginning of the sixties he was given several opportunities to fill a museum or 'chapel' with his works, and he used these installations to create a space that all who entered felt was truly sacred. He hung the works almost edge to edge, and dimmed the lighting. Enclosed, embraced by his silently luminous forms, visitors sought in vain for adequate words. Strangely, these experiences depressed him. Was it that, having come to such numinous power, being offered, too, optimum conditions for its experience, he began to despair of 'the further shore'? He began to paint less and less; very little was done throughout 1962, and at the end of the decade the weight of his despair killed him. *Number 1, White and Red* is one of the last of the large oil paintings in which Rothko still felt free to build up to the pure radiance of white. But it is a tremulous whiteness, a glowing cloud that thins to reveal a rich blueness beneath. It seems almost to need the sober brightness of the red, one of Rothko's favourite colours, though from now on mostly to be associated with black, (except in the more casual works on paper). Quietly brooding at the foot, there emerges a wonderful purple-plum colour, as if the artist's thoughts are steadily ascending: dark at the base, modulating to a severe joy and then floating away into rapture at the top. All rests, is held within a velvety darkness. Maybe even here, even before his life's anxieties overthrew his mind, Rothko is making visible the perpetual context of all experience, the darkness of suffering, whether seen or not. But it is a pain capable of the most exquisite chromatic sensitivities, a redeemable pain, a pain that will lift us up to God if we will accept its mystery.

Oil on canvas
102 ×
90 inches

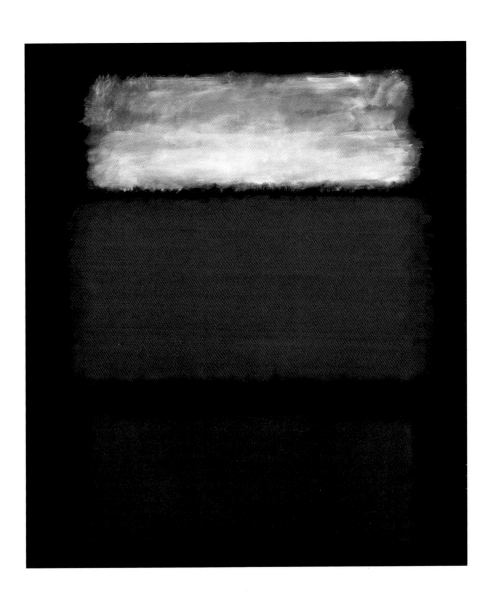

Jean Rustin

The Dark Room (1991)

Jean Rustin is a French painter who for most of his life has painted brightly coloured abstractions. But over the years, as he has aged and matured, his themes have changed, until finally he has found himself forced into a strange kind of dark figuration. These works are dark both literally and in substance. Some people have found them terrifying, others depressing, still others as suffused with a tender compassion that asserts the invisible presence of One who compassionates. It is not human compassion we are touching on. Here humanity is helpless. These victims live in a dark room, a closed room, we cannot get through to them. Yet they, through the artist, get through to us. The people he paints are desperately wounded by life. They are usually senile, old, poor, uncared for: the forgotten little ones of the earth. If not actually senile, they are so mentally retarded that there is little difference. Without any sense of their dignity, they are equally without a sense of shame, and naked or clothed means much the same to them. In this tender depiction, is Rustin asking us to think of our own nakedness and its concealments? Naked Adam and Eve knew they were naked because of sin: these poor ones are innocent. They need not fear exposure, as we do, concealing not wretchedness of body, but of soul. Rustin does not exempt himself. He has a self-portrait of his own anxious and exposed person, hands gripped tight in protective fear, eyes reddened with the tears of failure. He shows himself alone. The five people in *The Dark Room* are a family: father, mother, grandparent and two children, all alike in bodily condition and mental confusion. They do know vaguely that they are some sort of unit, despite the aloneness, and there is a touching sense of mute support as they each stare vacantly out at the hostile world that rejects them. But with what dignity they look out at us, having lost the ego–dignity that protects humanity in its pride. 'Having nothing, they have all things.' They do not even know, cannot by definition know, that they are treasured by God. They live in a true Dark Night, stumbling in total blindness. As Rustin illumines them so gently, so reverently, the dark room of their life takes on a mystical value. Here negatives are developed, and the True Image may appear.

Acrylic on
canvas
51 × 76¾
inches

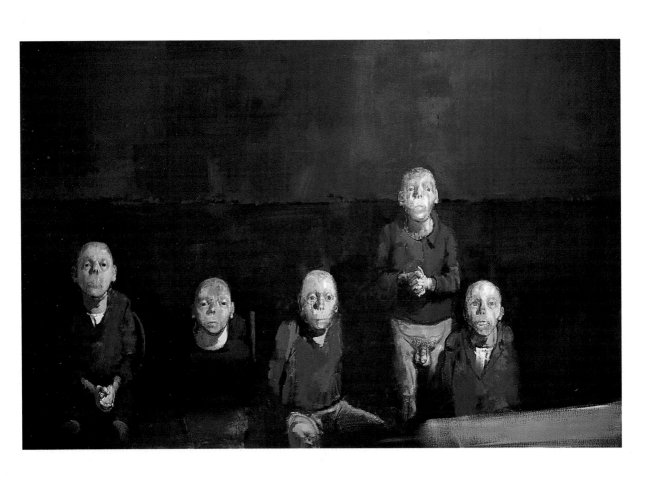

Rebecca Salter

Untitled (1990)

Rebecca Salter's work is always a unique combination of creation, destruction, and recreation. First she draws with great boldness and freedom onto prepared paper. But she can surrender at this depth to creative possibilities only because she knows that, once she has made her marks with absolute freedom, she will then tear or slash the paper and reduce her original work to fractions. It is only with these fragments, these scattered irresolute pieces that she can finally 'build', integrating them into a new order and a new beauty that is far deeper than the first freedom. The final work is always and of necessity 'untitled'. There is no figure or even theme to draw into a title the delicacy of what we are given. There *is* a theme, and the work itself is a sort of 'figure', but both are too mysterious, too unearthly, to be capable of being verbalized. Salter has made something extremely beautiful, that can move the viewer to tears. But what exactly it *is* remains integral to the silence with which her work is most intimately imbued. It asks us to open to it, in trust, to let it shine upon our hidden heart, and share itself with us. In this, the process as well as the result, Salter's work is essentially spiritual. God too asks us to be as true and free as is in us, and then to accept in faith that things not in our control will destroy and tear up much that we have confidently made. Only in prayer can we accept that His destruction of all we prize is the only way by which we can become more than we of ourselves could ever imagine. Love – prayer – will take us out of our certainties, away from our own will, however noble. It will seem to undo even our spiritual life, so that we are reduced to a painful nothingness. Yet, only in this ego–nothingness can Jesus become our Everything. When we read in St Paul about Jesus 'being our holiness', it sounds a lovely concept. In actual practice, nothing could be more terrible or more frightening than to have no holiness at all that is our own. If understood, it throws us helplessly on God for Him to make of us *His* work, His silent 'Untitled', whose name only he can know.

Mixed media
on paper
38½ × 38½
inches

Sean Scully

No Neo (1984)

Asked why all his work was based upon the use of the stripe, Sean Scully gave a straightforward answer: 'Stripes simply interest me'. The real question, of course, is why they should hold this abiding fascination for a highly inventive painter. As this title indicates, he has no time for art that relies upon the concepts of previous decades and instead rethinks them. His art is wholly personal, and yet he has insisted: 'My works are not just about me. I want them to address something larger . . . I'm not interested in self-expression.' Although Scully is quicker to tell us what he does not want to do than what he does, this is to the good, forcing us really to look at his art and try to account for the impact it makes. *No Neo* makes no secret of being formed out of several canvases, fitting together more or less, but harmonizing rather than blending. The left looks like wooden slats, primitive and roughly carpentered together. The centre is all the more imposingly vertical for its wavering volumes. The singing yellow and the blue lean against each other, unafraid of competition. The right repeats the centre but is abruptly cut off to admit horizontals of pinky-browns and browny-pinks. The combinations seem vulnerable, but alive, almost the result of nature rather than of art. Scully has confessed that he seeks to make art that is 'powerful and delicate, both at the same time . . . massiveness . . . become extremely delicate'. This is the secret of their beauty, perhaps. We are not ourselves perfect, and never can be. Perfection, for us, is loving God totally in the terms of what we actually are. And we are human, not angels. We have disturbing emotions, inherited weaknesses; we are wounded by our individual histories, scarred by wrong and foolish choices. Yet here we are: how to love with such contradictions? Scully shows us how. *No Neo* makes no pretence of a false unity, it offers no bravura challenge. It takes the diversity of its parts and unites them in its honesty. The frailty of the work is emphasized in its very name. *No Neo* accepts not to rely on the past but to stand nakedly in its own truth. The artist has faith in it as beautiful, and our Creator, our God, has faith is us.

Oil on canvas
96 x 120 inches

Richard Serra

Fulcrum (1987)

Richard Serra is a difficult sculptor. He wants his work to be public, yet not in any sense decorative, what he calls 'a bauble . . . signifying cultural awareness'. He abjures parks and lawns, museum sites, places where he feels the art is seen as 'art', somehow referring to the artist, 'self-referentual', allowing the viewers to escape from the impact of the work itself by its apparent distancing from their workaday environment. Serra therefore takes up the challenge of creating works that exist independently of himself, altering the sites in which they stand, and hence affecting the people who use those sites. *Fulcrum* is one of his prop-works, where the only force used to keep the massive plates of steel upright is that of gravity. Enormous slabs of Indated steel lean against one another amidst the ceaseless to-and-fro of a busy London station complex. If one diverts even slightly from the crowds streaming down onto the railway platforms for their trains, one can enter the enclosed space around which the great structure rears itself on high. One can stand as if in an igloo, shut off from the traffic of the busy world, and see above a clear-cut segment of clouded urban sky, distant and pure, light detached from confusion and made available for the gaze. Two feelings bear down upon the awed spectator. One is of the sheer massiveness of the work, its imperviousness to the swirling pedestrian traffic, its serene inviolability amidst the commotion. 'There is one condition I want,' said Serra, 'a density of traffic flow.' The contrast is part of the work, and if we do not notice it, we miss the wholeness of what is there to be experienced. Most of those passing through the Broadgate Street Complex do not even seem to realize that *Fulcrum* is a work of art at all, continuing onwards without a glance of recognition, let alone of respect. Serra has expressed great anger when his work, as has happened already to several of the prop-pieces, is removed to a quieter environment: confrontation is an inbuilt necessity; we ignore it at our spiritual risk. But there is also a potential bodily risk here. *Fulcrum* is terrifyingly vulnerable. The great plates are literally surrendered to the frail force of the earth's motion: what if they should fall? It is the uniting of power and weakness that gives Serra's sculpture its sacred power. These narrow temples of the spirit signify to us our own bodily condition. They are as defiantly vertical as we are, as immersed in a noisy and dangerous world as any city-dweller, yet they maintain their integrity and do not rely on an external source of integration. They accept that they are as they are, and summon us to be, likewise, as we are – or could be – all the warts seen and discounted.

Cor-ten
steel slabs

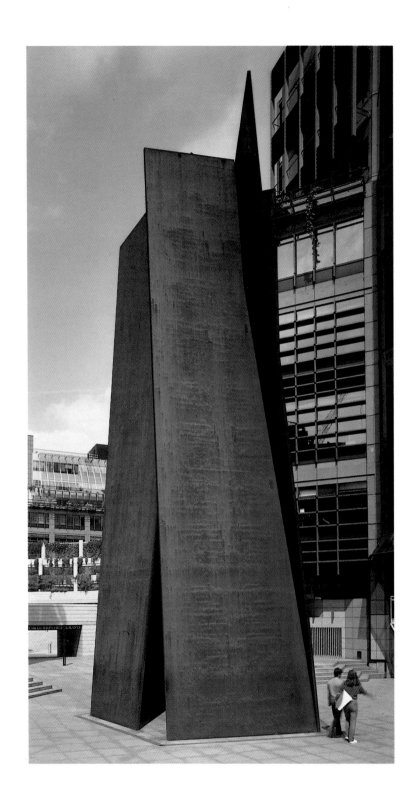

Alan Shipway

The Buddha in the Forest (1985)

Alan Shipway, though not a Buddhist, is greatly drawn, as we all should be, to the silent peace embodied by this holy teacher. Here he depicts the Buddha in the forest, not receiving revelation while contemplating beneath the sacred bo tree, but receiving revelation all the same. In the forest of this world, we cannot find blessedness in material richness. Not only are the trees a dull uniform brown, with the leaves as dark as the branches, as monolithic of form as the trunks, but the very greenness of the grass and the brightness of its flowers has been reduced to a faint ochre. The pond is pure white, and the holy teacher is white, too. The limpidity of the water, its responsiveness to reflected colour and event, expressing but never possessing what it shows, is highly appropriate for a symbol of a saint. Holiness means receiving from God all He chooses to give, pain as well as joy. It is not, of course, that God actually sends us pain, but it comes through the very process of living and is potentially therefore a way in which the divine can come to us. Pain can purify away the darkness of selfishness, leaving us 'pure' – and so can joy. But the Buddha is not entirely white. Just as the sky above, that image of heaven where God is totally glorified, is most delicately flushed with the promise of blue, so is the Buddha. His head, that part of the body where we think and choose, is gently coloured with azure, and as we look we see more and more azure, most strongly in the frontal torso, by tradition the seat of the emotions, and in the lower legs. There is no doubt as to the source of this blue, because the one sole brightness in the painting comes from the small bird towards which the Buddha stretches out a hand. It is not a bird in flight, but a grounded bird, hidden in the undergrowth of the great forest. Is it a symbol of humankind, born to soar in the freedom of happiness yet deeply aware that we have lost our wings? Yet this small bird has its wings, its capacity for bliss, and we could read the downstretched hand as encouraging it to fly again, as protective and tenderly affirmative. However we read the image, it is one of ineffable tenderness. It is also one of a most touching poverty. Everything is so unobtrusive, so humble in its means and shapes. All the bombast of the ego has been bleached out of the saint: it is his freedom from serious self-concern that enables him to see and recognize the bird of bliss. His holy reverence is for the shared givenness of both bird and human: both created, both loved, both blessed.

Acrylic on
canvas
37 × 29 inches

Yuko Shiraishi

. .

White in Shadow 5 (1990)

Five times now Yuko Shiraishi has entitled a work *White in Shadow*. All her work has much the same format: great wavering columns of colour bloom, fade and blend into one another, textures changing as subtly as the luminous colours themselves. (She uses combs, scrapers, saws, any rough instrument that will ruffle the surface of the paint and set it free to move across boundaries.) But the *White in Shadow* paintings, different as they all are, share a mystical stillness that makes them seem of the essence of her art. Shadow, by definition, is never still. It is a reflex, a sign of the earth's slow circling beneath the distant sun. As the shadow plays across whiteness, it unveils it in its delicate variety of hue. Shiraishi does not show us a blankness of white or a solidity. Her lyrical art draws us into the experience of whiteness, its infinitely gentle statements that are so wholly non-verbal and even non-figurative. She is not concerned with showing us a white 'something', but of inciting us to lose ourselves in the contemplation of spiritual purity. She wants us to immerse ourselves, with her, in the silence that art alone can open to us. 'I want the painting to be like the sea – you soak in it, like swimming.' The sea, that natural mystery, perpetually the same and perpetually different, is a good image of her art. At first it can seem uneventful. Then as we give ourselves up to looking, all its momentary lights and shades begin to engross the eye, and we are taken beyond the confines of the dominating intellect to a very quiet and beautiful enhancement. On one level, nothing to see; on another, everything. Or again, on one level, utter stillness; on another, the deep personal involvement that is indicated by her half-humorous comparison of the way she works to 'Sumo wrestling, where there are long ceremonial pauses, between quickly fought bouts'. Shiraishi stays motionless for long periods, letting the work call forth its own energies. Then she passionately engages in the bout of painting. As we look at *White in Shadow 5* the same clear earnestness is quietly called for. Accepting the responsibility of looking is an act of religion, a form of true and demanding prayer, radiantly fulfilling.

Oil on canvas
83⅞ ×
78 inches

Mary Sipp-Green
Nightshift (1991)

Nightshift was painted in the small mill town in New England where Mary Sipp-Green has her studio. It is a strangely lonely picture: no cars in the vacant lot, only one light visible in the mill where – we presume – people are at work. The silence is almost palpable, and the glimmer of the streetlight seems only to emphasize earthly spaciousness that is not only unfilled but seems painfully unfillable. In this solitariness Sipp-Green becomes free to look upwards, and there discerns the true 'nightshift', the uncanny movement of the night skies. She shows us unexplained streaks of ominous cloud and, hovering over the mill, glowing densities, scattered pinkly to the left, solidifying into purple on the right. There is a change going on overhead, and though it may literally only be a change of weather, what the artist intuits has a deeper significance. The real shifts in our life-patterns, she hints, may well take place in the night. Darkness and sleep are the time when we relinquish daytime dominance. At night, we lie down – that most vulnerable of positions – and allow the buried emotions of our dream-life to rise from the subconscious. In this, sleep has always been seen as a symbol of our prayer. Prayer is essentially beyond our control, as is our sleep. It is not sleep, of course, except in the sense that Scripture suggests: 'I sleep but my heart watches'. Prayer is a relinquishment of practical activity, a laying down of the desire for occupation or entertainment. Our sole occupation in prayer will be to wait on God, and that may entail the emotional blank that Sipp-Green depicts in her empty town. Yet the light tells us that this is in fact a scene of great activity; at night the mill is fully at work. If prayer gives us no emotional satisfaction, that may be the means to offering it more purely to God, whose work it essentially is. With only one light, that of faith, we accept that He is at work. We look up with the artist to the far skies of faith, allowing the inexplicable movements there into our actuality. We shall never make ourselves holy, but in accepting our human darkness, we are opening ourselves to the Light of Him to whom 'darkness is not darkness', in whose Light we see Light.

Oil on linen
32 ×
38 inches

Stanley Spencer

Christ Rising from Sleep in the Morning (1940)

'I love to dwell on the thought', said Stanley Spencer, 'that the artist is next in divinity to the saint. He, like the saint, performs miracles.' For Spencer, the 'miracle', the terribly difficult thing which as a man he could not manage, was to reconcile all his passions into a holy unity. He knew that sexuality was holy, and that selfless service was holy, and that communion with God was holy: but how to enter deeply into each and become, in the doing, holy himself? He failed as a man, but he succeeded as an artist, because only in art could all his 'various desires' come together to suggest what their final form would be, that form, 'the thing that ecstasy is about', that only God understands. Art for Spencer was an enraptured entrance into this hidden world of the divine freedoms to which he could only aspire in the confusion of his personal relationships. When these were at their most confused, he decided to paint forty sacred works, one for each day that Christ spent being tempted in the Wilderness. In the end, he only painted about eight, but they are his purest and deepest works, as if the sheer agony of his mistakes had forced him to cling to God with total resolution. *Christ Rising from Sleep in the Morning* shows us the clumsy peasant figure that Spencer often used to represent Christ – an almost generic Christ, the 'man who loves the Father and serves Him'. Jesus shoots from sleep into prayer, like a diver heading upwards. There is no interval, thinks Spencer: to be awake is to be in the presence of God. Christ is like a great flower-heart, the red earth of his desert surroundings like petals, fissured with the drought of human need for God, and He Himself the central stamen. Spencer loved the innocence of vegetable sexuality, which could be accepted without the challenge our fallen nature can find in depictions of human nakedness. The symbol of the erect stamen is sexual but sexuality seen as holy, as a way to God. This is essentially what it is meant to be, and what poor Spencer himself so longed to experience and share with others. But it is because Christ is totally loving that He can become this symbol, and the lonely desert indicates that we are surrendered to God only if we are prepared to sacrifice the selfishness of the ego. If we are prepared, then God will raise us up into His 'morning'.

Oil on canvas
102 ×
90 inches

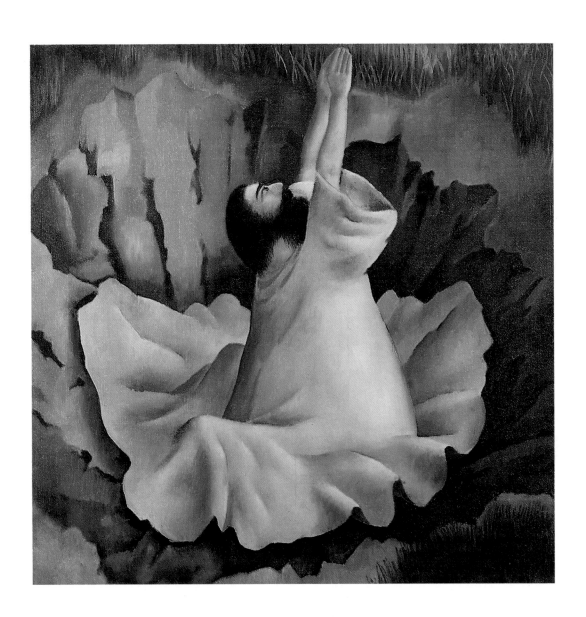

Pat Steir

Everlasting Waterfall (1989)

Pat Steir often paints in a series, caught by some image that she is compelled, it would seem, to investigate from every artistic angle. This sense of theme, of being one aspect of a greater whole, is silently present in *Everlasting Waterfall*, giving it an extra weight of significance. There are other *Waterfalls*, the theme is almost infinite, but we do not need to see in actuality the others in the series: *Everlasting Waterfall* sums them up with great authority. The great canvas is awash, from top to bottom, with the rushing power of this darkly glittering water. Water falls with a crash, an impetus, a magnificent ferocity that awes the viewer. And this is an everlasting fall: from some secret source these floods will continue to arise and sweep majestically down in all their emphatic disarray. On and on, weight after weight, eternal. The wonder of this painting is to be both light and dark simultaneously. Is it a night scene, with moonlight shining on the torrential downpour? The waters move before us as we gaze, defying the darkness and yet embracing and ratifying it. This is darkness overcome because accepted. This is life, that perpetually moving experience that we cannot halt while we get it into manageable order. Life sweeps us on, down and over, everlastingly in motion. We are not in control, and never can be. Yet, as the wonderful radiance of this picture suggests, (so subtle, so pervasive), our helplessness is a humiliation but not an obstacle. We need not fight to control, to regulate, to slow down the flood. That is the business of God, the source of living water. It is He who unlooses the cascades and it is He who will bear us along in their waters. To where? Only He knows. But in our prayer we explicitly acknowledge that our life is not our own. We are God's. Knowing this, willing to believe in it whatever our fear or pain, we choose the way of inner peace that accepts all the violence and speed as under His control. This is not to say He wants it thus, only that we have His assurance that, whatever happens, He Himself will carry us through it into love. He will bear us along, not despite the waterfall, but because of the waterfall, turning it to His purposes. And the purposes are 'everlasting': they are love.

Oil on canvas
108 ½ x
95 inches

Pia Stern

History of Man (1989)

History of Man is a large painting: eight foot long and five foot wide. But it is entitled after a large subject, and it needs the expanse and the impact it makes to be worthy of such a theme. Pia Stern works from that delicate divide where abstraction and figuration meet. She is at home in both worlds, fusing body and soul, as it were, to create artistic life. History of Man is a wonder of etherial azure, deepened and lightened by a subtle variousness of hue and texture. White streaks stray across it, black markings loom out from it. Some of these whites and blacks tempt us to 'read' them: is that a towered fortress on the horizon, and that spirally pallor on the right, is it cloud or vapour or curtaining? Maybe it is none of these. The sphynx-like creature that dominates the work keeps, like the sphynx, its secret. We get a sense of time immemorial, of layers of history, of mysteries buried and mysteries revealed but uncomprehended. We can delight in reading these multiple forms, but the real beauty is precisely that we can never come to a certainty about their true significance. That they have a significance, and that this is our own human story, seems inescapable. We are all challenged and involved in the work. But we are summoned to contemplate it with reverence. 'Lord, what is man that Thou art mindful of him, mortal man that Thou carest for him?' 'Man', of course, is humankind, not just the male half of it, and Stern is not making a divisive point here. She is marvelling – in the utmost beauty of creation, human creation, her own creativity – over the enigmatic progress of this strange creature. That God loves his creation is evident in the artist's very depiction. It is a work luminous with love, both tender and tough, refusing to give easy answers but celebrating that there is indeed an answer. It is, though, an 'answer' we are not equipped to understand, only to celebrate. The levels of prehistory are held up to the light of the artist's own integrity, there to be shared with us, respected and acclaimed, but never written off as solved. Stern brings all her great sensitivity to bear on this account of what has made each of us, artist and viewer, human. If we look long and lovingly at her work, it takes us to a fresh awareness of this mystery. There are dark and terrible things in human history, but they are all subsumed in the radiant colour of being 'not our own', of being the poor but beloved children of a heavenly Father.

Oil on canvas
60 ×
96 inches

David Tindle

. .

The Table, Early Morning (1991)

Still life is by definition a contradiction in terms, since life is never 'still'. Yet the description seems profoundly apt for David Tindle's works, even when they are not really still life works at all, but portraits or landscapes. Stillness in itself is the most remarkable quality of Tindle's art. He makes stillness visible, draws us into its quietness, silences us without an idle gesture. In a delicate and reticent manner Tindle sets before us what is supremely beautiful. It is generally completely ordinary as well, hence the Tindle magic. At last we learn how to see. *The Table, Early Morning* makes us free of two worlds, the inner and the outer; they interpenetrate, the landscape veiled in a soft haze yet unmistakably strong, vigorous, abiding; the house interior illuminated in all its vulnerability. The table seems to open itself to the light from without, exposing its treasures without concealment. With one exception, they are nature's own treasures, yet it is only humankind that sees their sacred quality. It is a human hand that has gathered the shell and the egg, both so fragile, that has carefully plucked the dandelion head, which one puff of wind or even breath will disintegrate. The bottle alone is of non-natural provenance, yet it too expresses an awareness of mortal frailty. It is used – it is an empty bottle – as this is an empty seashell, and this an egg that will not mature into a bird. The brittleness of glass echoes the unprotectedness of the shells, all containers that depend for their functioning on a benign handling. The cut pear takes this dependence a stage further: it will soon decay, laid out as if on a dissecting table. Yet it is laid out with gentle reverence. This table is in its secular way an altar. Early morning with its dim trees and air of expectation; quiet table set with slight yet wonderful creatures: one strong in its own right; one dependent on human care; both unified by the light, streaming with a luminous purity over all that Tindle sets before us. It glimmers with pale clarity on the windowsills, the walls, the thick moss-green of the tablecloth; it shines on the sacrificial body of the pear, plays with the roundness of the egg and the complex convolutions of the sundered bivalve that supports it, makes translucent the empty bottle and the puffball flower. Set free from the encompassing walls, the same light shimmers in the distances we see without, lyrical with the promise of a new day. The entire light-filled scene is one of acceptance. The world comes across to us as wholly innocent, totally without threat. We are asked to stand still in the sunlight and open our minds and emotions, limpid and still as the scene itself. Tindle makes no claim whatever to depict the sacred, yet the presence of God could well be imaged like this: unobtrusive, all-pervading, beneficent, loving, beautiful.

Egg tempera
on canvas
43 × 32 inches

Sally Warner

Persimmon Tree (1987)

Sally Warner is one of the rare artists who are impelled into drawing rather than painting. The sheer forms of nature, the patterning and the substances, overthrow her emotionally with their wonder, their intimation of the 'something beyond'. She copes with this intensity of response by re-expressing natural shapes in her charcoal exactitudes. She has no truck with cloudy generalizations. What she sees is specific, and is worthy of a specific response, unique to itself, unrepeatable. This drawing, *Persimmon Tree*, has the subtitle *September*. Warner travels fairly often, lured by photographs of distant lands, but she is open-eyed to see the delicate presence of the beautiful in her own Californian backyard. This exquisite *Persimmon Tree* only reveals its abstract grace when we have taken time really to see it. Although 'tree', there is no visible trunk, no setting in the actual world. Without any seeming need for a context, the 'tree' lets down to us its leafiness and its solitary ripeness of fruit. Sunlight almost palpable dapples the leafy twigs, plays around the sweet plum-like fruit. Some leaves vanish in the sun's brightness, some create shade for one another, and remain visibly present. Each is individual to itself, this leaf, this fruit, this hot September when the glory of the mature and fertile garden needs no underpinning, but can be taken out of context and revered for its own sake. This self-forgetfulness in a natural phenomenon is the secret of Warner's power. She has been influenced by the ancient artists of China and Japan, and has used their poetry for inspiration. 'Everything must begin in silence, and into silence it vanishes', is a favourite line, and it has a moving relevance to *Persimmon Tree*. Silence is never a negation of speech. Rather, it transcends speech, enabling us to enter the sanctuary where words are not only superfluous, but actively damaging. If we think we can 'speak' our truth, we are never free to accept the Unspoken and Unspeakable glory of God. The absence of an earthly trunk for this tree, its obliquity of perspective, its seeming freedom to offer us fruit from above, reaching down to us: all this may have, in Warner, a hidden, mystic significance.

Charcoal on paper
34 × 48 inches

Richard Kenton Webb

The Rubicon (1988–89)

The Bible is the primary source of Richard Kenton Webb's inspiration, or better – if this is not irreverent – it is the God who reveals Himself through the Bible that inspires him. Webb is no mere illustrator; it is the divine meaning that he loves and celebrates, and this is most often clearest when transposed in human terms that are closer to our contemporary thinking. For the same reason, he makes visual use of Dante, who saw biblical teaching in specific visions of the people and places known to him. *The Rubicon* is not a biblical river, but the moment of decision is a profoundly biblical concept. Moses asked the Israelites to 'choose this day between death and life', and it is truly this choice, though perhaps not recognized, that meets each of us each day. Webb is a supreme colourist, drawing us to his work by its sheer beauty. Here in *The Rubicon*, we see two worlds, both beautiful: the near world where we are at home, and the far world that is still unknown to us. To cross this river, to make this irrevocable decision, we must alight from our horse and contemplate what lies before us. Webb's man, whether the historical Caesar who first crossed this boundary and 'committed' himself, or Everyman, is a small dim figure in the vastness of the world. Easy for him to feel that not very much depends upon his choices. We know from Roman history how intimately the future of the Roman world, (which became the Christian world), was bound up in the lonely decision made by this one man, on his own lonely responsibility. The near side, where the figure is at home, is dappled with sunlight. It may seem rather barren, but it is easy riding country, and the trees, clearly storm-tossed and still battered, are at least familiar. But the river runs deep and on the other side is utter mystery, a deep mountainous blueness, offering no sure access. *The Rubicon* is about the loneliness of choice, and its necessity. Turning back means staying where it is safe but barren; plunging into the waters means embarking upon the dangers of the uncontrollable. Webb tells us, implicitly, simply by the heavenly blue of the post-Rubicon shore, that commitment is into the Hands of Love. But the choice is ours.

Oil on canvas
18 ×
14 inches

Carel Weight

The Battersea Park Tragedy (1974)

As a child, Carel Weight knew a great deal of loneliness and fear, and as an adult he has accepted the pain of his personal history and made it fruitful in his art. God cannot 'redeem' our past unless we first acknowledge it. Nothing is wasted, it is essentially a means to some sacred end. Weight has said of his work that it 'is concerned with such things as anger, love, hate, fear and loneliness, emphasized by the setting in which the drama is played'. It is always a drama, one that the artist feels only unfolds itself to him as he paints it, and we share with him the wondering shock as the narrative is played out. *The Battersea Park Tragedy* commemorates a real event, when one of the overhead cars at the fun fair jumped off the track and children were killed. The grieving woman in the picture wears a mourning armband, and is clearly desolate with a huge sorrow. But what strikes us primarily is the frightening constriction of her world. There are two worlds here. She lives in one where all is dark and imprisoning: walls, fences, railings, nets. It is a geometrical world where even the bare trees are able only to wave forlornly from behind their enclosures. The lines of the tennis court speak of rules, a world that plays understandable games. Yet the horror is that the rules do not always hold. The imprisonment does not bring safety. At the Fun Fair the game broke down, and yet the steel supports of the game still dominate the skyline. If the woman would only look up though, only turn her bowed head, she would be made free of another world. The sky is radiant with the liberty of the formless sunset, and through it moves a shadowy angel. He does not draw attention to his presence, and he hides the beauty of his face behind his own grieving hands. It is not that heaven is unaffected by our sorrows, only that they are there seen in perspective. Weight has confessed to a fascination with 'the ever-present immanence of danger and disaster, of the sudden, unexpected, often terrible happening'. We are always at risk. But the horror of the risk needs to be set in the actuality of its context, and the angel silently suggests that the rapturous fires of the evening sky convey a deeper message. Freedom and beauty are there for the seeing: we have only to open our eyes.

Oil on canvas
72 ×
96 inches

Anthony Whishaw

Landscape II (1990)

Anthony Whishaw aligns himself with the Romantic artists, at least in the sense that the Romantics 'want to take on board something greater than themselves, almost more than they can manage. It's a way of trying . . . to create something that uncovers unexpected feelings and emotions.' Whishaw is profoundly committed to the 'uncovering' of the 'unexpected'. Although his work is based on figurative perceptions, it is more the anticipation of a reality that interests him. He speaks of the image being 'at its most powerful just before it is perceived'. Before we pin labels to things, locking them away in the certainties of recognition, we have a rare opportunity to 'see' them in their truth. This is the area in which Whishaw is active, catching the wonder of the world before it is obliterated by familiarity. As an Englishman, this may be what has drawn Whishaw so obsessively to Spain over the years. In this landscape, so unlike the disciplined greeneries of his native land, he is set free to catch the strange wild beauty of the earth on the wing, as it were, liberated into vision precisely because it is strange. *Landscape II* has a radiant inner glow, all ochre and pale fire. We see the world as infinitely large, glowing and sunbaked in all directions. In this uncharted desert, the small village, un-named, clustered compactly for protection, displays a brave insistence on regulation. Its roofs and patios, its vertical thicknesses of wall and patterned sedateness of roofing and flooring, all react against the encompassing heat of the Spanish plateau lands. Along the left there runs a pattern of non-objective slats, like venetian blinds, (an image that has a special significance for Whishaw), making it clear to us that this is not a realistic 'landscape', but the idea of one, the interior reality of the land and its humble inhabitants. Whishaw has remarked that 'the fact that humans have passed through a landscape means that they have inevitably left their mark'. Literally, there may no longer be a village here. Spiritually, the village is there for ever. We pass through the world, affecting it. For all its rich beauty, Whishaw's is a sad painting, conscious of human passage, of the shortness of life, of the need to cherish, to individualize, as he does with such reverent care.

Acrylic and
collage on
canvas
4 × 10 inches

Elizabeth Williams

Nothing Covered or Hidden No.1 (1989)

Elizabeth Williams works in sequence, and this is only the first of the three images that make up *Nothing Covered or Hidden*. One of her main reasons for using the form of sequence, she says, is that 'it places meaning within a given context, within the dialogue between images'. She wants to challenge 'the traditional notion of a photographic image "fixing" or "capturing" a moment in time, or revealing a supreme instant which points to an ultimate reality'. And yet Williams's work is all about this 'ultimate reality': it is only that she knows from within that it can never come in a single image. Of its nature it is, if not triune, then at least multiple. The Holy presses silently upon us from every direction and we must look on all sides to see it in its true form. This first image, No.1 of *Nothing Covered or Hidden* shows us the sea drawing back over sand. It is infinitely gentle, translucent water, water abdicating its fierce potential. But even in this faintest of forms, water leaves its impression on the sand, and the other two images in the sequence show the image from other aspects. No.3, still ethereal, is all sandiness, sand moved, touched, changed by the water. In none of these three images, washed as they are with luminous colour, do we actually see the tide, the wash over the sandy firmness. All we see is the delicate yet definite effect. For Williams, whose art is all concerned with the presence of the Spirit, un-named, revered without the vulgarity of address, the presence of this unseen sea is a powerful metaphor. Water, she has observed, 'symbolizes survival through flexibility and strength through endurance'. This is the Taoist tradition, while for the Christian, it is a baptismal force, purifying and renewing. The Old Testament says very beautifully: 'The waters saw Thee, O God, the waters saw Thee and trembled.' These 'trembling waters' that wash so purely over the grit of the seashore bear light within their liquidities. The sand submits to their action, as we must to God's. The sequence of *Nothing Covered or Hidden*, a title taken from the Apocalypse, referring to the human heart and its call to be exposed to the divine verdict, tells us that we have no need to fear: who wants to hide from Love?

Chromogenic
development
print
21¼ × 14½
inches

Jane Wilson

Silent Green (1990)

I f it were not for the moon, fertile and hazy, in the upper lefthand corner, *Silent Green* could be taken as an abstract. Jane Wilson is not intent on describing to us the actualities of the scene, though the scene is positively present, a great low sweep of water, edged by the blue acclivities of the far side. Above spreads an immense openness of luminous sky, and we feel that it is this openness, this light-filled rapture of space, that holds Wilson entranced. Real spaciousness is not truly an external thing. It is in ourselves that we are either free or bound, either exposed to God or shielded from His Holy energies by the small enclosures of our ego. To let the light shine in, to offer no resistance, to go on into eternity at either end, no boundaries, no demarcations, no 'mine' and 'God's': this is holiness. Is this the unspecified subject of *Silent Green*, which moves us far beyond its apparent theme? Exposure like this is beautiful to the viewer, (us before this painting, God before our prayer), but it has to accept a divine lack of excitement. We sense here that the light will change, that the moon will disappear when the sun rises, that the colours we see are subjectively and not objectively there, passing effects of an essentially temporary state of time and season. But we do not actually experience this passing. What we are shown is static, reliant for its beauty on inner tranquillity. For ever, this pale moon will glimmer above and the motionless waters lie below. We shall not see the light in the sky change. This blessed monotony is often what most afflicts us when we pray. Outside prayer, (as far as anything can be called 'outside' it), life is in continual and interesting flux. But time given contemplatively to God, time not spent in meditating or doing good, time spent waiting on His pleasure: this time can seem dull. Even the great St Teresa admits that there were periods when she watched the clock hopefully. Gazing at a work as utterly beautiful as Wilson's *Silent Green*, it is good to remember that prayer is for God's delight, not our own. He alone sees how we look within, and, we earnestly hope, takes delight in it.

Oil on linen
36 x 50 inches

List of Illustrations and Acknowledgements

The publishers would like to express their gratitude to all the artists, galleries, museums and private collectors who have been so very helpful in providing visual material or permission for the reproduction of works of art within this book. Every effort has been made to ensure that the credits given below are accurate, and apologies are offered for any acknowledgements inadvertently omitted.

Roger Ackling,
Colonsay, Inner Hebrides, April 1987

Courtesy the Artist, and Annely Juda Fine Art, London

———————

Norman Adams,
The Way of the Cross and the Paradise Garden, 1988

Private Collection

———————

Craigie Aitchison,
Christmas Painting, 1988

Courtesy the Artist

———————

Frank Auerbach,
Head of JYM III, 1984–5

Courtesy Marlborough Fine Art Ltd, London

———————

Roderick Barrett,
Players, 1989

Courtesy the Artist

———————

Elizabeth Blackadder,
Still Life, Nikko, 1987

Courtesy Mercury Gallery Ltd, London
Photo Geoffrey Allen

———————

Mel Bochner,
Ricochet (9.11.81) 1981

Courtesy Sonnabend Gallery, New York

———————

Louis Le Brocquy,
Image of Picasso, (detail) 1983

Courtesy the Artist
Collection Musee Picasso, Antibes

Caravaggio,
Death of the Virgin

Collection Musee du Louvre
© RMN

———————

Maria Chevska,
Convulsive Cloak, 1989–90

Courtesy the Artist

———————

Cecil Collins,
Head of a Fool, 1974

Courtesy Elizabeth Collins, and Anthony D'Offay Gallery, London

Virginia Cuppaidge,
Eye of the Calm, 1988

Courtesy the Artist
Photo D James Dee

———————

Richard Diebenkorn,
Ocean Park 109, 1978

Collection The Cleveland Museum of Art, Mr and Mrs William H Marlatt Fund, and gift of the Cleveland Society for Contemporary Art and an anonymous donor

———————

Judith Dolnick,
Mystery, 1990

Courtesy the Artist

———————

Michael Finn,
Flying Crucifix, 1990

© Michael Finn 1990
Collection John and Ella Halkes
Photo Bob Berry

Helen Frankenthaler,
Waxing and Waning, 1985

© Helen Frankenthaler 1992
Courtesy Andre Emmerich Gallery
Private collection

———————

Franz Gertsch,
Doris, 1990

Courtesy Turske & Turske AG
Private collection, Switzerland

———————

Goya,
The Countess of Altimira and her Daughter

Courtesy The Metropolitan Museum of Art, Robert Lehman Collection, 1975
© 1975 By The Metropolitan Museum of Art

———————

Anne Grebby,
A Fire to Burn, A Wind to Freeze, 1991

Courtesy the Artist

———————

Maggi Hambling,
Smiling Sunrise (3), Suffolk 16.8.87, 1987

Courtesy the Artist

———————

Marcelle Hanselaar,
Chronicle of Wasted Time, 1987

Courtesy the Artist
Photo Irene Rhodes

———————

Dereck Harris,
Singular Figure, 1988

Courtesy the Artist

Be' Van Der Heide,
Kaş, 1990

Courtesy the Artist

———————

Albert Herbert,
Jesus is Stripped of His Garments II, 1987

Courtesy England & Co, London W11 2RP

———————

Paul Hodges, *Paho*, 1990

Courtesy the Artist

———————

James Hugonin,
Untitled (IV), 1990

Courtesy the Artist
Private Collection, London
Photo Eileen Tweedy, London

———————

Andrzej Jackowski,
Holding the Tree, 1988

Courtesy Marlborough Fine Art Ltd, London

———————

Bill Jensen,
The Vanquished, 1982–83

Courtesy Steve Martin, California, and Grob Gallery, London

———————

Jasper Johns,
Map, 1962

© Jasper Johns/DACS, London/ VAGA, New York 1992
Courtesy Leo Castelli Photo Archives, New York

Mark Rothko
No. 1, White and Red, 1962

© 1992 Kate Rothko-Prizel &
Christopher Rothko/ARS, NY
Courtesy Art Gallery of Ontario,
Toronto
Gift from the Women's
Committee Fund, 1962

Jean Rustin,
The Dark Room, 1991

Courtesy Mary Boone Gallery,
New York

Rebecca Salter,
Untitled (F79) 1990

Courtesy the Artist
Private collection, London

Sean Scully,
No Neo, 1984

Courtesy Waddington Galleries
Ltd, London

Richard Serra,
Fulcrum, 1987

© 1992 Richard Serra/ARS, NY
Courtesy Stanhope Properties plc,
London

Alan Shipway,
The Buddha in the Forest, 1985

Collection of the Artist

Yuko Shiraishi,
White in Shadow 5, 1990

Courtesy Edward Totah Gallery,
London

Mary Sipp-Green,
Nightshift, 1991

Courtesy the Artist

Stanley Spencer,
*Christ Rising from Sleep in the
Morning*, 1940

© Estate of Stanley Spencer 1992
All rights reserved DACS
Collection, Art Gallery of
Ontario, Gift from the Women's
Committee, 1962
Photo Brenda Dereniuk, AGO

Pat Steir,
Everlasting Waterfall, 1989

Courtesy Robert Miller Gallery,
New York

Pia Stern,
History of Man, 1989

Courtesy Jeremy Stone, 20th
Century American Drawings and
Paintings, San Francisco
Collection Jim and Joanne
Dickson, Oakland, California
Photo Sixty St Studio, San
Francisco

Tiepolo,
Martyrdom of St. Agatha

Courtesy Gemaldegalerie,
Staatliche Museen Preusischer
Kulturbesitz, Berlin
Photo Jorg P Anders

David Tindle,
The Table, Early Morning 1991

Courtesy Fischer Fine Art Ltd,
London

John Virtue,
Landscape No. 75, 1987–88

Courtesy the Lisson Gallery,
London
Photo Gareth Winters, London

Sally Warner,
Persimmon Tree, 1987

Courtesy the Artist
Collection the Southern California
Spinal Center

Richard Kenton Webb,
The Rubicon, 1988–89

Courtesy Benjamin Rhodes
Gallery, London

Carel Weight,
The Battersea Park Tragedy, 1974

Courtesy The Metropole Arts
Gallery, Folkestone

Anthony Whishaw,
Landscape II, 1990

Courtesy the Artist
Photo Susan Ormerod

Elizabeth Williams,
Nothing Covered or Hidden (No 1 in
a series of three), 1989

Courtesy the Artist
Collection the Royal
Photographic Society

Jane Wilson,
Silent Green, 1990

Courtesy Fischbach Gallery, New
York
Photo Plakke/Jacobs, New York